IMAGES
of America

DETROIT'S DOWNTOWN MOVIE PALACES

JUL

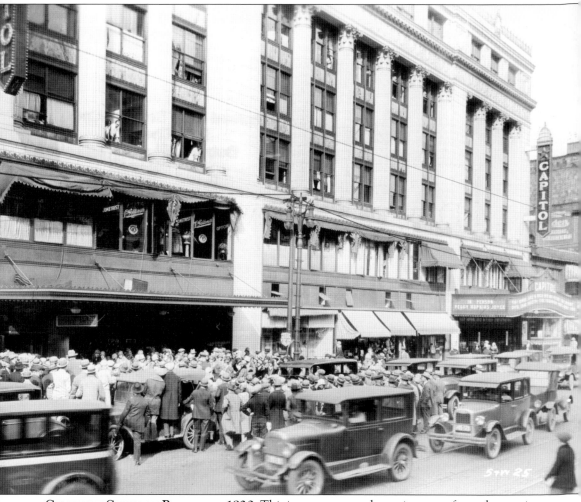

CELEBRITY CRUSH ON BROADWAY, 1930. This image captures the excitement of crowds storming the Capitol Theatre (today's Detroit Opera House) to see Peggy Hopkins Joyce. Joyce was a 1920s blonde film star and former Ziegfeld girl who became famous for marrying millionaires. Broadway was a much busier street then with several major streetcar lines stopping at the Capitol's front door. (Courtesy Burton Historical Collection, Detroit Public Library.)

On the cover: Please see page 47. (Courtesy Manning Brothers Historical Collection.)

IMAGES
of America

DETROIT'S DOWNTOWN
MOVIE PALACES

Michael Hauser and Marianne Weldon

ARCADIA
PUBLISHING

Published by Arcadia Publishing
Charleston SC, Chicago IL, Portsmouth NH, San Francisco CA

Printed in the United States of America

Library of Congress Catalog Card Number: 2006927647

For all general information contact Arcadia Publishing at:
Telephone 843-853-2070
Fax 843-853-0044
E-mail sales@arcadiapublishing.com
For customer service and orders:
Toll-Free 1-888-313-2665

Visit us on the Internet at www.arcadiapublishing.com

Dedicated to the foresight and determination of all the men and women who have toiled through the years to provide future Detroiters with the lasting legacy of these magnificent multifunctional theaters

CONTENTS

Acknowledgments 6

Introduction 7

1. Monroe Street and Environs 9

2. The Move to Grand Circus Park 23

3. The Capitol Theatre 45

4. The Michigan Theatre 61

5. The Fabulous Fox Theatre 73

6. The United Artists Theater 91

7. The Wilson Theater 103

8. The Gem and Telenews Theaters 113

9. Lost but Not Forgotten Theaters 121

ACKNOWLEDGMENTS

We gratefully acknowledge the assistance of the following individuals: Alyn Thomas of the Manning Brothers Historical Collection, Sharon Arend of the Fox Theatre Archives, Thomas Featherstone of the Walter P. Reuther Library at Wayne State University, the staff of the Burton Historical Collection at the Detroit Public Library, Richard Sklenar of the Theatre Historical Society of America, Patience Nauta, and Cynthia Young.

INTRODUCTION

Other than the former downtown Detroit movie palaces, few buildings (with the possible exception of Hudson's) evoke the fond, personal memories that generations of families are able to pass on to their loved ones. For some, it is remembering their favorite place to sit, others it is their first kiss in the balcony, their favorite candy counter treats, or even their trip down on a streetcar or bus. A hot summer afternoon, cooling off at a matinee with a soda and freshly popped corn, now that was the way to truly enjoy an afternoon. For a number of folks, working in a movie palace was their first job, either as an usher, a ticket taker, or in concessions.

Detroit has always been at the forefront of film exhibition. When reviewing the history of how downtown Detroit's movie palaces evolved, one word certainly comes to mind, and that is visionary.

Little did Arthur Caile or John Kunsky realize that their small 200-seat theater on Monroe Street would develop into a chain of plush movie palaces. Their Casino Theater opened in 1906 as Detroit's first commercial movie house. Reportedly, it was the second movie theater in the world. Both Caile and Kunsky began their careers in the penny arcade business. Kunsky, with the assistance of George Trendle, his accountant, later bought out Caile. Kunsky and Trendle foresaw the possibility that Grand Circus Park could evolve into a dazzling entertainment district. Their empire grew to 20 theaters, and in 1929, these astute businessmen sold their theater chain to Paramount Pictures Publix Division for $7 million.

Architect C. Howard Crane was also instrumental in the development of Grand Circus Park as an entertainment destination. He designed the Fox, State, United Artists, Adams, Madison, and Capitol (today's Detroit Opera House) theaters, three of which are successfully in operation today. Additionally, Crane designed the 1926 Film Exchange Building on Cass Avenue. Detroit was the first city in North America to have a facility devoted specifically to the motion picture industry. This seven-story structure included a screening room, film vaults, regional movie studio offices, booking offices, and collateral businesses where posters and press material could be obtained.

Mervyn Gaskin took a risk on Cinerama for Music Hall. His initial intent upon purchasing this venue was to book traveling theatrical productions, but he was shut out by the Shubert Organization. By chance, Gaskin met a Cinerama executive on a flight to Detroit who was seeking theaters for this new adventure in cinema. Music Hall, the second theater in North America to feature Cinerama, opened with *This Is Cinerama* in 1953 and became one of its most successful franchises.

Bill and Crystal Clark operated Clark Theater Service for more than 40 years. They booked many of the downtown palaces. Bill was a doorman and his future wife worked the candy counter

at Detroit's Chandler Theater. They loved the business so much, they began their own successful film booking service.

Shan Sayles came from humble beginnings at the Krim Theater on Woodward Avenue near Six Mile Road. In the 1950s, he became the marketing manager for United Detroit Theatres. Sayles's outgoing personality was perfect for the many stars he had to shuttle around for media opportunities. Today he owns his own group of theaters in California.

Nicholas George was another visionary who, once he created a successful chain of suburban theaters, came downtown in the 1960s and saved the Grand Circus, Michigan, and Telenews theaters from closing. He was the only exhibitor at the time willing to take a risk downtown.

Odd as it may seem, the kung fu, blaxploitation, action, and horror films of the 1970s and 1980s provided the downtown palaces with life support. Detroit's real estate values were so depressed, no one wished to purchase the theaters for new development.

Modern-day visionaries began with Charles Forbes, who took early retirement from Ford Motor's real estate department and purchased the Fox, Gem, Century, and State theaters in the late 1970s. Forbes saw the potential for these faded palaces and devised a master plan for a theater district, which then paved the way for Michael and Marian Ilitch to purchase the Fox Theatre, restore it, and eventually renovate other structures in the neighborhood.

Dr. David DiChiera's dream for Detroit to have a home for opera came true in 1996 with the renovation of the former Grand Circus Theater as the new home for Michigan Opera Theatre. DiChiera mounted a capital campaign to restore the former palace during tough economic times. Michigan Opera Theatre has evolved into one of the top 10 opera companies in North America.

The diversity of today's restored palaces is what has made the Grand Circus Park Entertainment District successful. It has become a home for dance, opera, concerts, Broadway, and many special events. The buildings themselves have come full circle from live entertainment to exclusively films and now back to live performances.

One

MONROE STREET
AND ENVIRONS

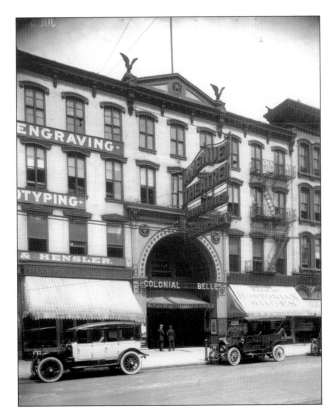

FROM RECITALS TO BURLESQUE. The Avenue Theatre was constructed in 1859 as Merrill Recital Hall at 400 Woodward Avenue. From 1886 to 1901, it was known as the Wonderland Theatre, a vaudeville house. Following the Wonderland's move to Campus Martius, the theater was extensively renovated and reopened as the Avenue, a 1,000-seat burlesque theater. It was demolished in 1950 to construct the City-County Building. (Courtesy Walter P. Reuther Library, Wayne State University.)

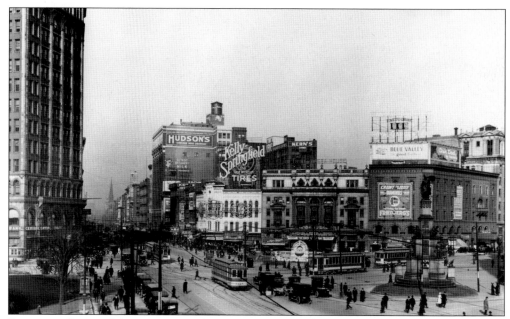

BUSTLING CAMPUS MARTIUS, 1916. Campus Martius was the gateway to Detroit's entertainment and shopping district. Note the Detroit Opera House in the center, with the Wonderland and Temple Theatres to the right. At this time, there were 11 theaters between Campus Martius and Randolph Street: Bijou, Casino, Columbia, Comique, Detroit Opera House, Family, Liberty, Lyceum, National, Royale, and Temple. (Courtesy Manning Brothers Historical Collection.)

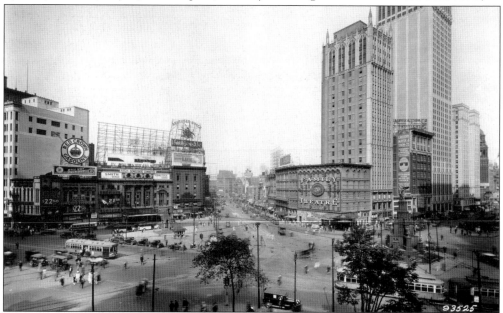

THE CAMPUS STRUGGLES TO MAINTAIN ITS PROMINENCE, 1928. By the late 1920s, most folks were patronizing the nine deluxe movie palaces that had been constructed from 1917 to 1928 surrounding Grand Circus Park, five blocks north of Campus Martius. The Monroe Street theaters began screening exploitation films or switched to burlesque to compete. (Courtesy Manning Brothers Historical Collection.)

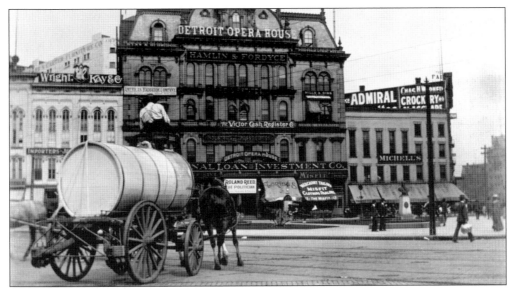

THE ORIGINAL DETROIT OPERA HOUSE ON CAMPUS MARTIUS, 1880s. Detroit's first opera house, opening in 1869, was designed by Sheldon and Mortimer Smith. This 1,700-seat venue was originally on the second floor and was located at 5–15 Campus Martius, above the space where Hudson's Department Store was founded. In 1887, Chicago architect Irving Pond completely renovated the venue, increased the seating capacity to 2,100, and relocated the auditorium to the main floor. The theater was destroyed by fire on October 7, 1897. (Courtesy Manning Brothers Historical Collection.)

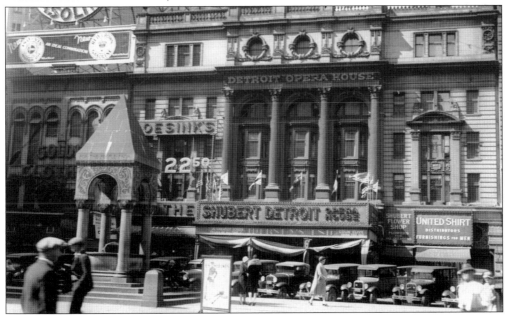

THE SHUBERT DETROIT OPERA HOUSE, 1930. Lee and J. J. Shubert operated the opera house from 1919 to 1931. The theater was not able to sustain itself during the Great Depression, and in 1931, the 2,200-seat venue was gutted for the creation of Sam's Discount Department Store. Sam's reigned supreme on Campus Martius until 1966 when the entire block was demolished. (Courtesy Walter P. Reuther Library, Wayne State University.)

DETROIT OPERA HOUSE PLAYBILL, 1912.
Following the 1897 fire, the Detroit Opera
House was immediately rebuilt. The Detroit
Opera House was Detroit's leading dramatic
theater from 1898 to 1931. All the major New
York producers scheduled their product here.
The opera house hosted the first screening
of a motion picture in Detroit in 1898 and
through the years screened a number of
blockbuster films. (Courtesy Michael Hauser.)

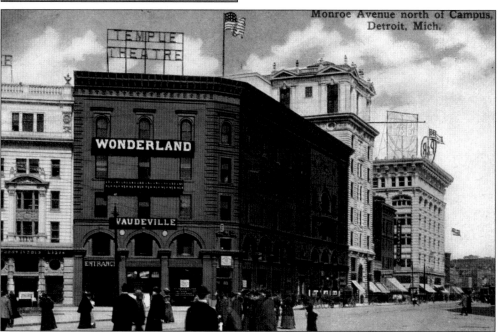

EARLY POSTCARD OF THE TEMPLE AND WONDERLAND THEATRES. The Wonderland Theatre
(formerly located on lower Woodward Avenue) moved to Campus Martius in 1901. It billed itself as
"the handsomest cheap-priced amusement palace in the world!" The theater seated 1,800 patrons
with continual performances. (Courtesy Michael Hauser.)

WONDERLAND THEATRE PLAYBILL, 1901.
Following a decade on lower Woodward
Avenue, the Wonderland moved to
Campus Martius in 1901. Its success was
a combination of vaudeville, animals,
museum-like displays, and circus sideshow
acts. The Wonderland Theatre shared an
auditorium with the B. F. Keith's Temple
Theatre next door, but the overwhelming
success of vaudeville at the Temple forced the
Wonderland to eventually close. (Courtesy
Michael Hauser.)

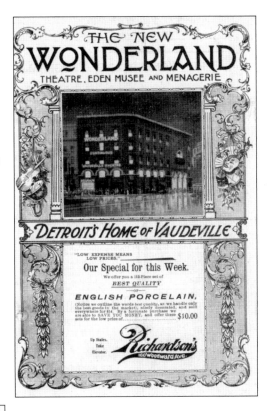

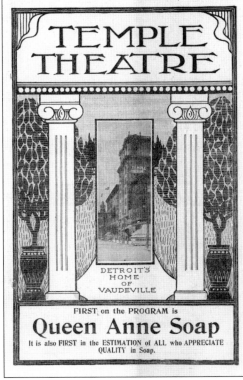

TEMPLE THEATRE PLAYBILL, 1900.
The Temple Theatre heralded itself as
being "devoted to the highest standards
of vaudeville!" A typical performance
included a stage show, a Pathe weekly
newsreel, and a silent film. Al Green led
the nine-piece orchestra for many years.
The theater was leased to the Keith Albee
Circuit in 1923. During the height of
vaudeville, hundreds of patrons were turned
away nightly, unable to secure the 10¢ seats.
(Courtesy Michael Hauser.)

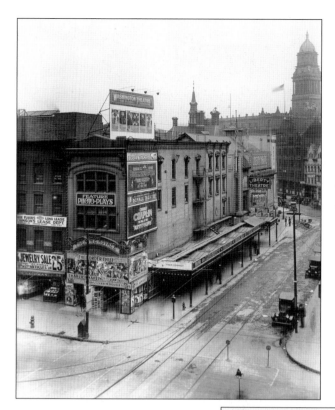

LIBERTY AND ROYALE THEATRES, 1917. The first multiple-reel motion picture was screened at John Kunsky's Royale Theatre, located at 100–102 Monroe Street, in 1910. *The Passion Play* broke house records and played here for 16 weeks. Popular conductor Eduard Werner began his career at the neighboring Liberty Theatre, leading a seven-piece orchestra. (Courtesy Manning Brothers Historical Collection.)

THE EMPRESS, A LONG-RUNNING SURVIVOR. This 300-seat theater opened in 1910 at 540 Woodward Avenue, the site of today's Comerica Tower. It was one of C. Howard Crane's earliest theater commissions. Alternating between films and burlesque, its slogan "[a] Good Show Always" remained on the facade until the theater closed in 1957. It was demolished in 1969. (Courtesy Burton Historical Collection, Detroit Public Library.)

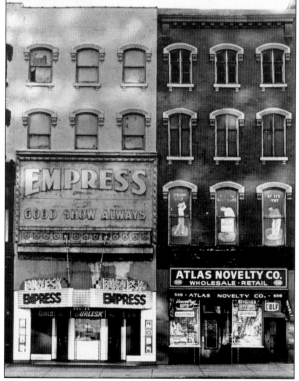

The Mutual Burlesquer

Vol. IV—No. 7 Week of October 8th, 1928 Price 10 Cents

CADILLAC
THEATRE
NEWS
DETROIT

Marie Breen in Merry Whirl

Published
Weekly
NEWS of
SHOWS
THEATRES
PLAYERS
and
CIRCUIT

CADILLAC THEATRE PLAYBILL, 1928. The Cadillac was located at 231 Michigan Avenue, west of Campus Martius, and upon its opening in 1912 was Detroit's largest nickelodeon theater. This 1,200-seat venue, designed by Gustave A. Mueller, was altered in 1913 by Mildner and Eisen for stage productions, vaudeville, films, and, later, burlesque. The Cadillac was initially booked by the national Pantages syndicate. (Courtesy Michael Hauser.)

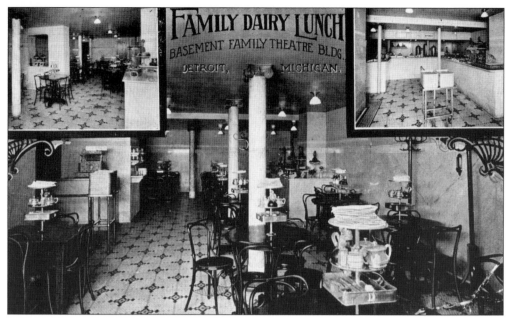

FAMILY THEATRE POSTCARD, 1913. The Dairy Lunch was located in the basement of the Family Theatre. Concessions within most theaters at this time were frowned upon. Specializing in vaudeville, the theater was carved out of the former Kirkwood Hotel and opened in 1909 with 900 seats. By 1914, a film policy was adopted, taking advantage of the excellent location at the convergence of several streetcar lines. (Courtesy Michael Hauser.)

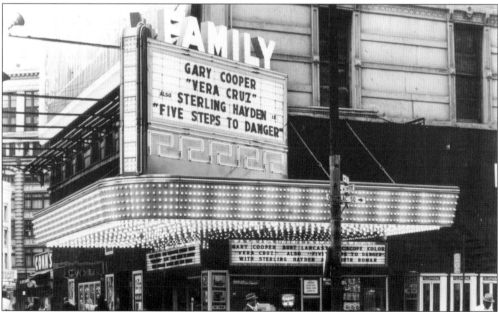

THE FAMILY THEATRE AT 1 CADILLAC SQUARE, 1957. By the 1950s, the "family" name did not quite correlate with the film fare on the screen. Titillation pictures frequently were booked, and by 1967, the theater was renamed the Follies, screening pornographic films. It literally went out with a bang in a spectacular 1973 blaze that destroyed the theater. (Courtesy Burton Historical Collection, Detroit Public Library.)

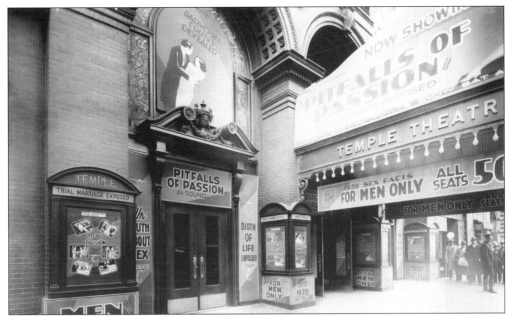

EARLY EXPLOITATION FILMS ON MONROE STREET, 1928. For most of its life, the Temple was the most popular vaudeville theater in Detroit, until a policy switch to films in 1928. *Pitfalls of Passion* was phenomenally successful, but thereafter, the theater struggled with a diversified schedule of films and special events, such as the J. L. Hudson Company Frolics, staged each year for employees. (Courtesy Manning Brothers Historical Collection.)

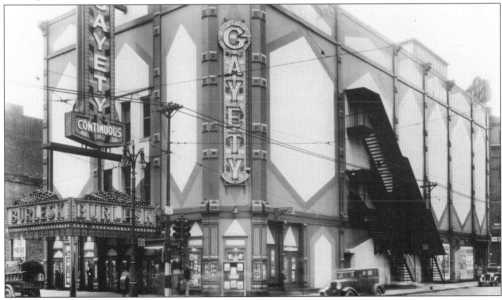

A NONDESCRIPT HOUSE ON CADILLAC SQUARE WITH LOTS OF HISTORY. The 1,300-seat Gayety Theater, designed by Fuller Claflin, was built exclusively for burlesque when it opened on September 15, 1912. Its motto was "always entertaining . . . but never offensive!" Famous stage acts who appeared here through the years include Mickey Rooney, Bert Lahr, and Abbott and Costello. The Gayety closed in 1958 and was demolished for parking. (Courtesy Burton Historical Collection, Detroit Public Library.)

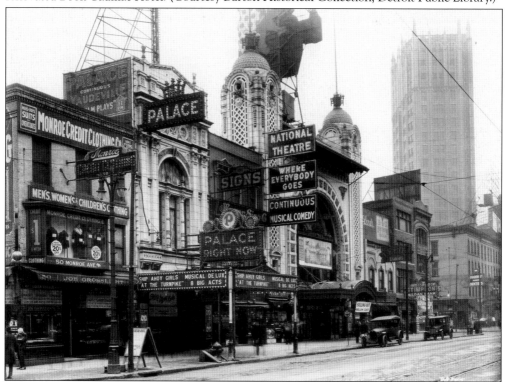

FINE ARTS THEATRE
WOODWARD AT CHARLOTTE OPPOSITE ADDISON HOTEL

THE BEST SHOWS IN TOWN

BLACKSTONE THEATRE
MICHIGAN AT GRISWOLD NEXT TO KINSEL'S DRUG STORE

—— DETROIT'S ——

OPEN = ALL = NIGHT THEATRES

NOW SHOWING

TALKING PICTURES

LOW ADMISSION PRICES

WESTERN ELECTRIC PERFECTED TALKING SYSTEM USED

CATERING TO THE THIRD-SHIFT PATRONS, 1929. This billboard heralds two of Detroit's 24-hour theaters. The Fine Arts was located just north of the Grand Circus Park Entertainment District, while the Blackstone was located at Michigan Avenue and Griswold Street, just west of Campus Martius. The Blackstone opened as the Jewel Theater in 1911. The 280-seat venue was renamed in 1918 and closed in 1934. The site today is set to become a parking garage for the renovated Book Cadillac Hotel. (Courtesy Burton Historical Collection, Detroit Public Library.)

THE NATIONAL THEATRE AND THE PALACE THEATER, 1920. These two venues were the jewels of the Monroe Street Entertainment District. The Palace, located at 130–132 Monroe Street, was designed by C. Howard Crane and opened in 1914. Despite its success, this venue closed in 1928. The National, at 118 Monroe Street, specialized in vaudeville, "no pictures, Detroit's ONLY all stage show!" It remains the lone survivor of the original Monroe Street Entertainment District. (Courtesy Manning Brothers Historical Collection.)

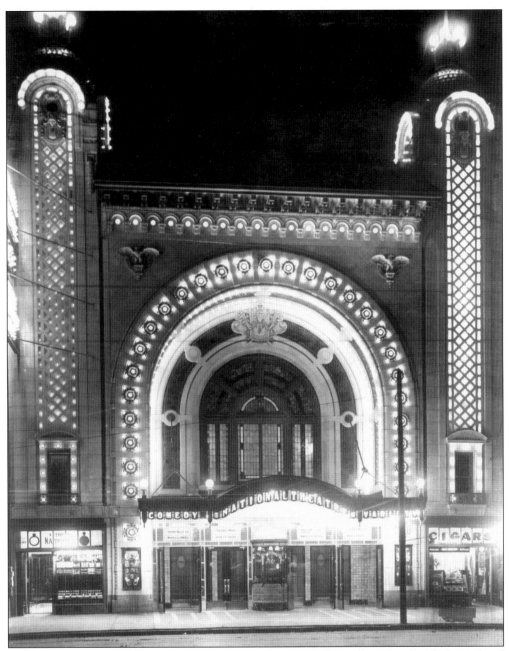

THE NATIONAL THEATRE ABLAZE WITH EXCITEMENT. The arched facade of white glazed terra-cotta, flanked by two domed towers, was originally studded with lightbulbs to highlight the unique architectural details of the exterior. The central arch contained several stained-glass windows, while the lobby entrance featured a vaulted ceiling lined with Pewabic tiles. This theater, whose slogan at one time was "where everyone goes," today stands silent and in poor condition, awaiting a savior. (Courtesy Manning Brothers Historical Collection.)

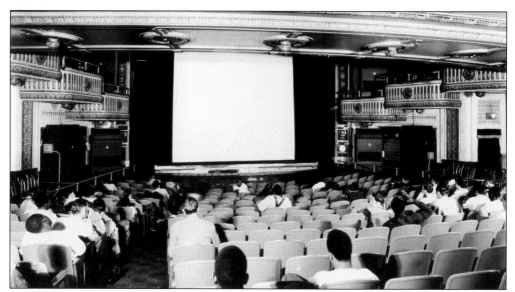

MATINEE AUDIENCE AT THE NATIONAL, 1948. This was the only major theater designed by famed Detroit architect Albert Kahn. This 800-seat venue opened on September 16, 1911, as a vaudeville theater, later augmented with photoplays. Later forms of entertainment included films and traveling burlesque. In the 1950s, management drew crowds by staying open 24 hours a day and by booking rock and roll and rhythm and blues shows. The theater closed in 1975 following a steady diet of action films and pornography. (Courtesy Burton Historical Collection, Detroit Public Library.)

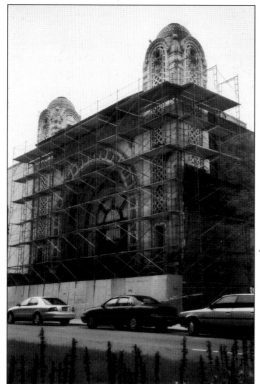

WHAT DOES THE FUTURE HOLD FOR THE NATIONAL? In 2005, scaffolding was erected to clean the terra-cotta facade of the theater. The owners had received a facade enhancement grant from the City of Detroit for Super Bowl readiness. In 2006, contractors power washed the facade and began repair to the terra-cotta. (Courtesy Michael Hauser.)

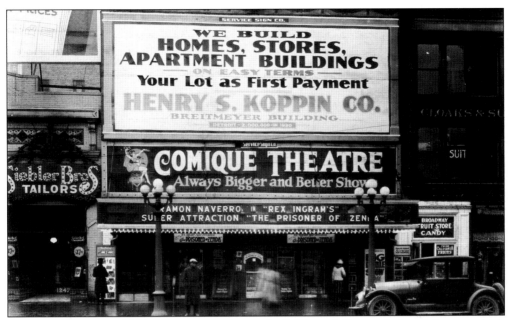

COMIQUE THEATRE, 1922. This was another early C. Howard Crane–designed theater, which opened in 1912 at 1249–1251 Broadway, near Gratiot Avenue. The slogan here was "the best show in town for the money!" In this image, *The Prisoner of Zenda* is being shown, starring silent film heartthrob Ramon Navarro. This venue closed in 1928. (Courtesy Manning Brothers Historical Collection.)

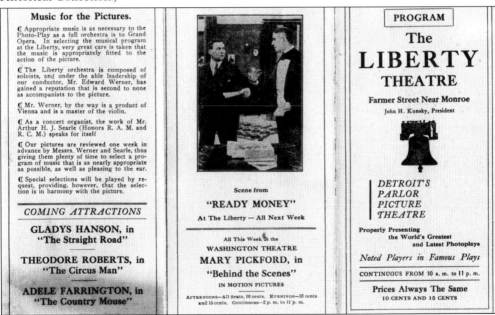

PLAYBILL FOR THE LIBERTY THEATRE. This venue, located at 1020 Farmer Street, was C. Howard Crane's second theater to open on or near Monroe Street in 1913. It was built within the shell of the 1871 Central Presbyterian Church. This house was proud to tell its patrons that "the pictures at the Liberty are as clear as a bell!" It closed in 1926 and was later demolished for a small office structure. (Courtesy Michael Hauser.)

PLAYBILL FOR THE BROADWAY STRAND THEATRE, 1916. A typical performance at this photoplay house included an overture by the Broadway Strand Orchestra, the weekly review, a soloist, an educational scenic, a tenor, a photoplay, a Mutt and Jeff comedy, and an exit march. Patrons were encouraged to leave their musical requests for the orchestra at the box office. (Courtesy Michael Hauser.)

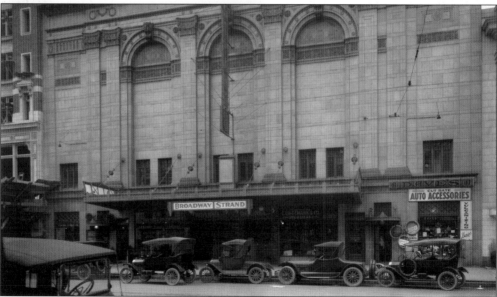

BROADWAY STRAND THEATRE EXTERIOR. This 1,600-seat neoclassical house opened in 1913 on Broadway near Gratiot Avenue, just east of Campus Martius. Architect Arland W. Johnson designed both this venue and the nearby Washington Theatre. Note the subdued entrance and lack of attraction boards. The main floor also housed three businesses. The theater closed in 1929 and was later demolished for a parking lot. (Courtesy Walter P. Reuther Library, Wayne State University.)

Two

The Move to Grand Circus Park

Bustling Grand Circus Park, the 1920s. This was an incredibly prosperous time for Detroit as indicated in this image of Grand Circus Park. Looking east, from left to right, is the Tuller Hotel, the world headquarters of S. S. Kresge Company, the Fine Arts Building, the Adams Theatre with illuminated rooftop spectacular, the Stroh Brewery Company headquarters, Fyfe's Shoes, Central United Methodist Church, and the Hotel Statler. (Courtesy Manning Brothers Historical Collection.)

JOHN KUNSKY, THEATER IMPRESARIO. John Kunsky is widely credited with opening the first commercial motion picture theater in Michigan, the Casino, on Monroe Street in 1905. He was in partnership with Arthur Caile, who had the vision to foresee the possibilities of film. Kunsky later formed a chain of Detroit's finest downtown, neighborhood, and early suburban venues. In 1929, he sold the company to Paramount Pictures Publix Division of theaters and, with business partner George Trendle, entered the radio business. (Courtesy Walter P. Reuther Library, Wayne State University.)

C. HOWARD CRANE, THEATER ARCHITECT EXTRAORDINAIRE. Originally from Hartford, Connecticut, C. Howard Crane moved to Detroit in 1908 and set up his architectural firm to specialize in theater design. Most of the major theaters in the Grand Circus Park Entertainment District were designed by Crane, as well as Orchestra Hall. With the Great Depression halting most construction, Crane became discouraged and moved to London, England. (Courtesy Michigan Opera Theatre Archives.)

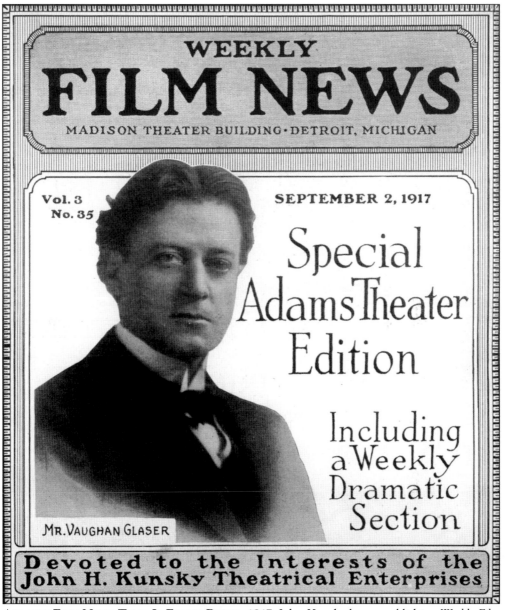

WEEKLY
FILM NEWS

MADISON THEATER BUILDING · DETROIT, MICHIGAN

Vol. 3
No. 35

SEPTEMBER 2, 1917

Special
Adams Theater
Edition

Including
a Weekly
Dramatic
Section

MR. VAUGHAN GLASER

**Devoted to the Interests of the
John H. Kunsky Theatrical Enterprises**

ALL THE FILM NEWS THAT IS FIT TO PRINT, 1917. John Kunsky began publishing *Weekly Film News* in 1915. By 1917, he incorporated a drama section into the magazine to correlate with the opening of the Adams Theatre. That same year, the publication was expanded to 24 pages, and free distribution was increased to 25,000 copies. *Weekly Film News* became the leading amusement magazine in Michigan devoted to the best in motion pictures, music, and drama. Kunsky referred to it as "my weekly souvenir to the theater going public!" (Courtesy Michael Hauser.)

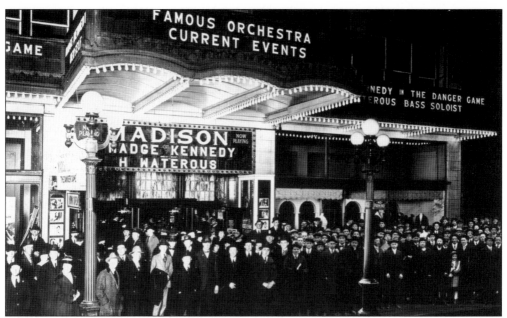

THE HUMBLE MADISON THEATRE MARQUEE, 1919. John Kunsky's Madison, at 22 Witherell Street, was the first theater to open on Grand Circus Park, on March 7, 1917. The venue opened with *Poor Little Rich Girl* starring Mary Pickford. The opening program also consisted of a Max Linder comedy, a Pathe-Hearst newsreel, a Pathe educational short, a tenor, a soprano, and the Madison Famous Orchestra and Organ. (Courtesy Manning Brothers Historical Collection.)

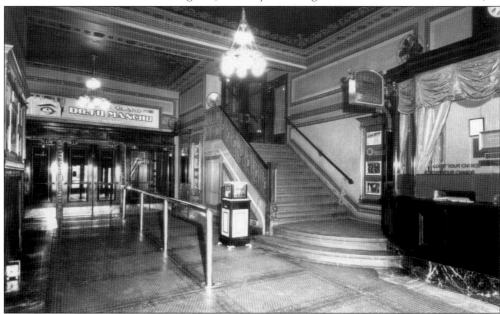

MADISON LOBBY ENTRANCE FROM WITHERELL STREET, 1929. The Madison had a long narrow lobby with the auditorium entrance on the left and stairs to the loge and balcony on the right. Continual performances ran daily from noon to 11:00 p.m. Kunsky's orders to all employees were simple: "courtesy first . . . last and always!" The Madison was also architect C. Howard Crane's first commission on Grand Circus Park. (Courtesy Manning Brothers Historical Collection.)

Madison Theatre Prior to Construction of Eaton Tower, 1926. The Madison rooftop spectacular was 60 feet high and 35 feet wide and a beacon for those traveling on southbound streetcars. Note the Capitol Theatre on the left, Hudson's Department Store in the background, and the upscale Newcomb Endicott Department Store on the right, which was absorbed by Hudson's in 1927. (Courtesy Manning Brothers Historical Collection.)

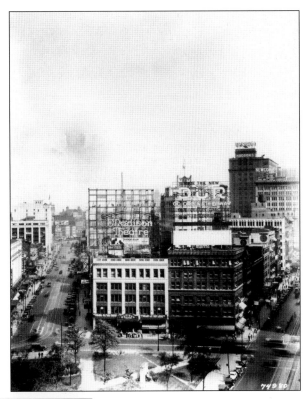

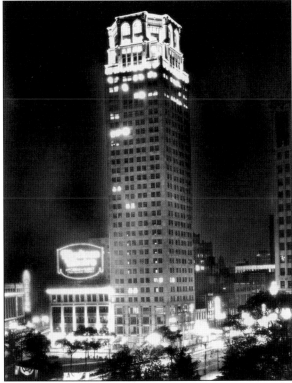

Illuminated Madison and Eaton Tower, 1927. By the late 1920s, Grand Circus Park became the hub for both shopping and entertainment. Additionally, the neighborhood was home to the city's finest hotels and restaurants and had developed a sizeable daytime office population. (Courtesy Manning Brothers Historical Collection.)

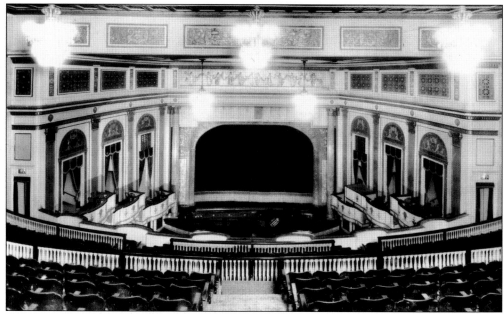

MADISON AUDITORIUM AS VIEWED FROM THE BALCONY, 1917. The initial cost to construct this neoclassical gem was $500,000. The velour stage curtains and rich artistic draperies throughout the theater were designed and installed by Newcomb Endicott. The organ was installed by Hilgreen Lane Company and, at that time, was the largest theatrical instrument outside of New York. (Courtesy Theatre Historical Society of America, Elmhurst, Illinois.)

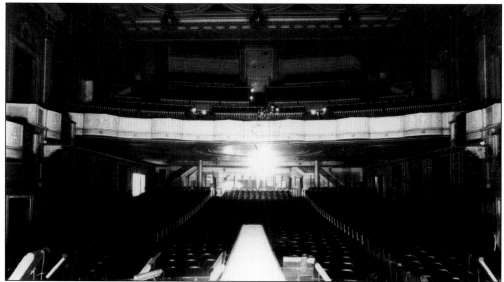

VIEW OF THE AUDITORIUM FROM THE MADISON STAGE, 1921. Upon opening, the Madison seated 1,207 in the orchestra, 744 in the balcony, and 48 in the boxes. The original screen size was 18 by 21 feet, and the stage dimensions were 25 feet deep and 63 feet wide. The Madison film policy in the 1920s was to run serious dramas. It was the first theater in Michigan to screen a full-length talking picture, *The Jazz Singer*, which opened on Christmas Day in 1927 and played to over 500,000 patrons in the following three months. (Courtesy Manning Brothers Historical Collection.)

Announcement

 CONOMIC conditions compel the management to make a slight increase in the price of admission to the Madison and Adams Theatres. This step has been taken only after long hesitation and is dictated solely by prevalent conditions in the moving picture world. Producers have had to face a greater cost in the making of their pictures for the coming season, and, as a result, there has been a corresponding increase in the rentals and the proper presentation of these pictures. ❦ ❦

The Madison and Adams orchestras, composed of the best musicians, have been granted a large increase in salaries starting September 1st. Each orchestra has also been enlarged by five musicians. A flat increase of twenty-five per cent has been given to the motion picture operators and a substantial increase to the stage hands and electricians, as well as to all the other employees of both theatres. ❦ ❦ ❦

In view of these conditions, and in order to maintain the high standard of the program at the Madison and Adams Theatres, it has become necessary to make a slight revision in the admission prices of both theatres. ❦ ❦ ❦

BEGINNING ON SEPTEMBER 14th

the new scale of prices will be as follows:

MATINEES

Main Floor—all seats	25c.
Main Floor—Loges	50c.
Balcony—All Seats	20c.
Balcony—Loges and Boxes	25c.

EVENINGS—SUNDAYS—HOLIDAYS

Main Floor—All Seats	50c.
Main Floor—Loges	75c.
Balcony—All Seats	30c.
Balcony—Loges and Boxes	50c.
Adams Mezzanine and Boxes	65c.

These prices include the usual war tax.

A DIGNIFIED WAY TO ANNOUNCE A PRICE INCREASE, 1918. Kunsky management, faced with escalating costs, utilized these handbills as a way to communicate an admission increase. At the time, the Madison staff, aside from management, orchestra, and ushers, consisted of two projectionists, two organists, a scenic artist, and a carpenter. (Courtesy Michael Hauser.)

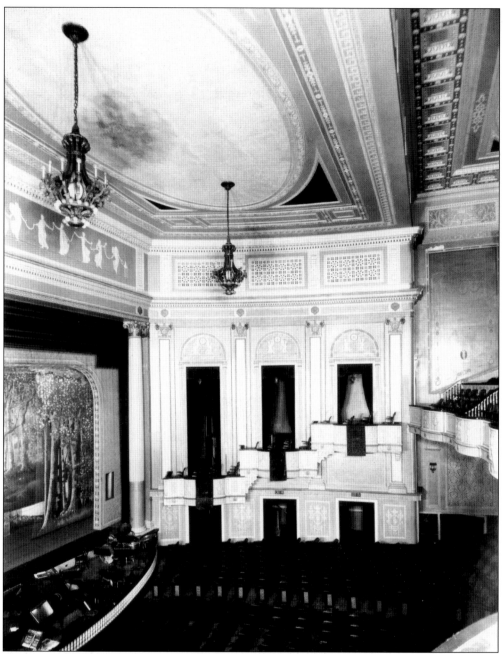

MADISON AUDITORIUM DETAIL, 1920. The auditorium, aside from some questionable paint colors, changed little from 1917 to the 2001 demolition. The side boxes were removed and covered with draperies. The chandeliers survived until the demise of the theater, and the dancing maidens on the proscenium were salvaged and can be seen in the Eureka Lofts on Broadway. (Courtesy Manning Brothers Historical Collection.)

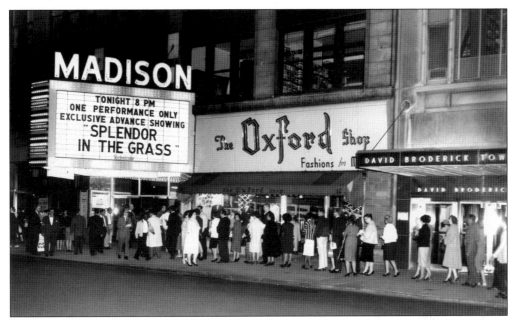

A Sneak Preview at the Madison, 1961. Film policy at the Madison varied through the years. First-run photoplays in the 1920s were replaced with a triple-feature policy in the 1930s. The 1940s saw a sub-run or move-over policy and by 1948, back to a first-run policy. The 1950s and 1960s saw many long-run road shows such as *Bridge on the River Kwai*, *The Ten Commandments*, and *Spartacus*. (Courtesy Central Business District Foundation.)

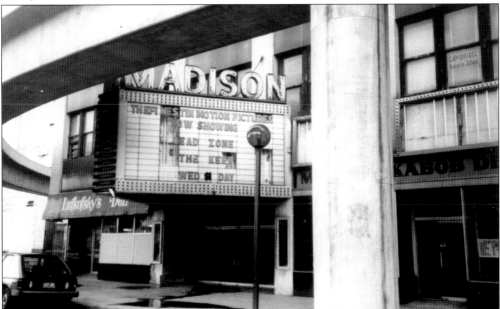

The Madison Is DOA, 1984. The changing demographics of Detroit prevented the Madison from securing first-run fare in the 1970s and 1980s. The theater went from a record 68-week run of *The Sound of Music* in the mid-1960s to youth oriented films in the mid-1970s (*Woodstock*) to early-1980s fare such as *Suicide Cult*. The final screen fare was Steven King's appropriately titled *The Dead Zone* in 1983. (Courtesy Michael Hauser.)

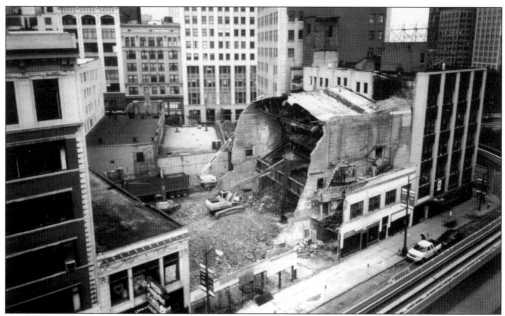

MADISON DEMOLITION, 2001. This theater lasted through several wars, the Great Depression, and social strife but could not survive demographic or film exhibition changes. A 1961 renovation provided the theater with life support for another two decades. By the 1980s, to supplement double features, management also rented the facility for stage presentations by the Peddy Players and for concerts such as Was (Not Was). (Courtesy Michael Hauser.)

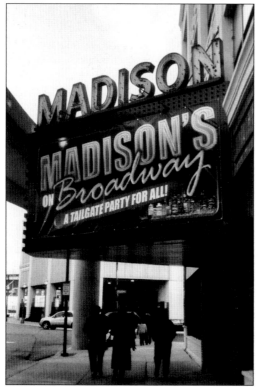

THE MADISON MARQUEE COMES ALIVE FOR SUPER BOWL, 2006. In February 2006, the marquee heralded Madison's on Broadway, a temporary lounge installed for the Super Bowl in the former lobby and retail space of the Madison Theatre. The auditorium had been demolished, but the office building was touted as being part of an office loft/bar and grill development. (Courtesy Michael Hauser.)

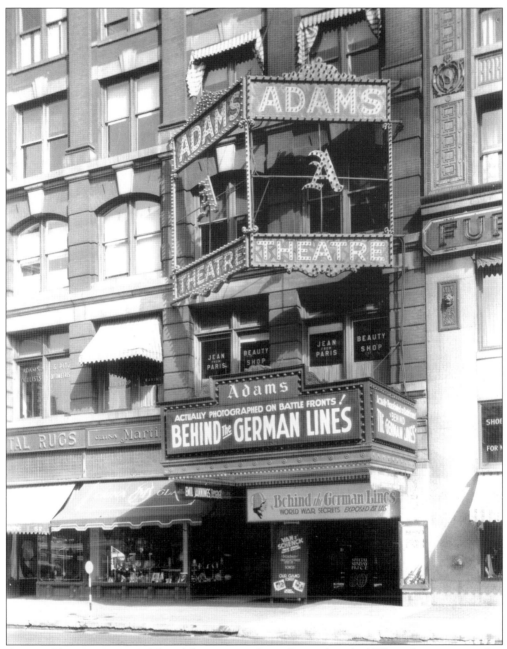

ADAMS THEATRE, 1929. The Adams opened on September 1, 1917, with a very modest marquee. The entrance was in the Fine Arts Building at 44 West Adams Street, with access to the auditorium via a bridge over the alley or a sloped walkway beneath the alley. Land values were so expensive facing Grand Circus Park that the auditorium was built on Elizabeth Street, hence the nickname "alley jumper." (Courtesy Manning Brothers Historical Collection.)

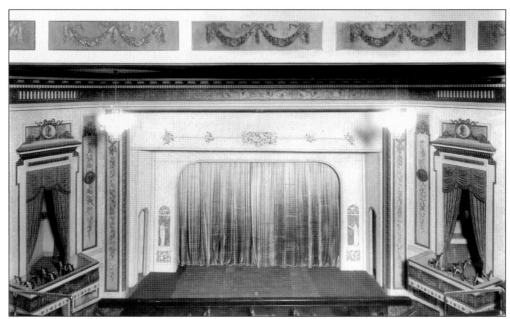

ADAMS AUDITORIUM AS SEEN FROM THE BALCONY, 1929. The Adams opened as a legitimate house with *Romance*, a stage comedy featuring the Adams Concert Orchestra, under the direction of Eduard Werner. Architect C. Howard Crane's neoclassical architecture was similar to the Madison, across the park. Within the first year of operation, John Kunsky converted the Adams to a motion picture venue. (Courtesy Manning Brothers Historical Collection.)

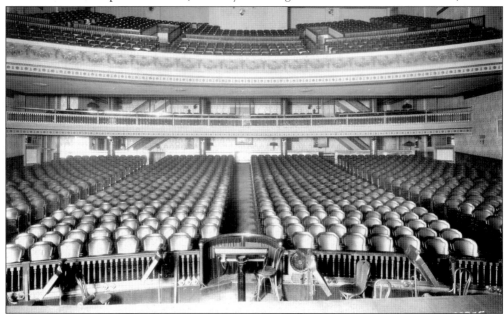

ADAMS AUDITORIUM VIEW FROM THE ORCHESTRA PIT, 1929. A typical program in the 1920s featured the orchestra, a topical review, a singer, an educational scenic, and a film. The Adams specialized in comedies. Initial seating for the house consisted of 934 orchestra seats, 178 mezzanine seats, and 652 balcony seats. The theater installed Vitaphone sound in 1927 for talking pictures. (Courtesy Manning Brothers Historical Collection.)

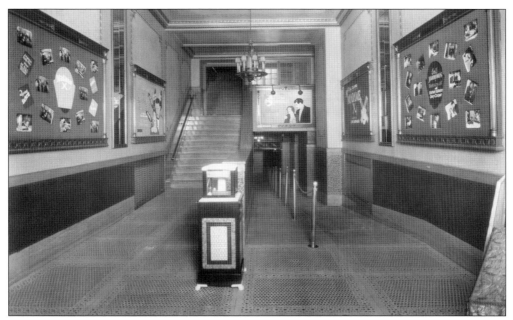

ADAMS STREET LOBBY, 1929. The austere lobby provided little clue of what one could experience upon entering the auditorium. The initial film screen measured 15 by 18 feet, the stage was 30 feet deep and 70 feet wide, and dressing rooms on several floors could accommodate 33 performers. A grand organ was installed in 1918, and shortly thereafter, the orchestra was enlarged by five musicians. (Courtesy Manning Brothers Historical Collection.)

ADAMS POWDER ROOM, 1929. Simple powder rooms and restrooms were located downstairs and on the balcony level. Because refreshments were not sold in most theaters until 1940, the need was not there for large or elaborate restrooms. Note the weight and fortune machine in the image above. In 1935, Balaban and Katz (B and K) Theaters of Chicago renovated and began managing the Adams. (Courtesy Manning Brothers Historical Collection.)

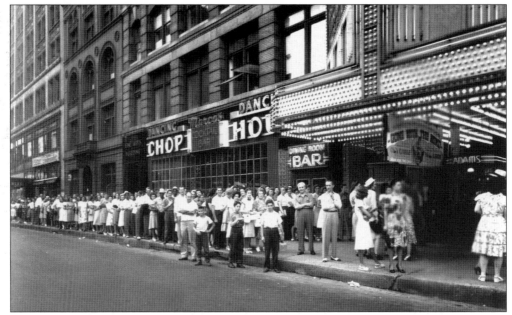

LINING UP ON ADAMS STREET, 1947. These folks are awaiting the next screening of a reissued *Gone With the Wind* at popular prices. In 1940, the Adams added the Teleflash Hour, which consisted of three newsreels from various sources and short subjects. Push-back seats were also installed and were billed as "the most important improvement in theaters since the advent of motion pictures!" (Courtesy Central Business District Foundation.)

CHANGING WITH THE TIMES, C. 1955. When most of the downtown movie palaces were built, the majority of patrons arrived via public transportation. As automobiles became more popular, patrons demanded convenient and affordable parking. The Adams Theatre had a prized location when the City of Detroit decided to construct the 900-space Grand Circus Underground Garage at its front door. (Courtesy Michael Hauser.)

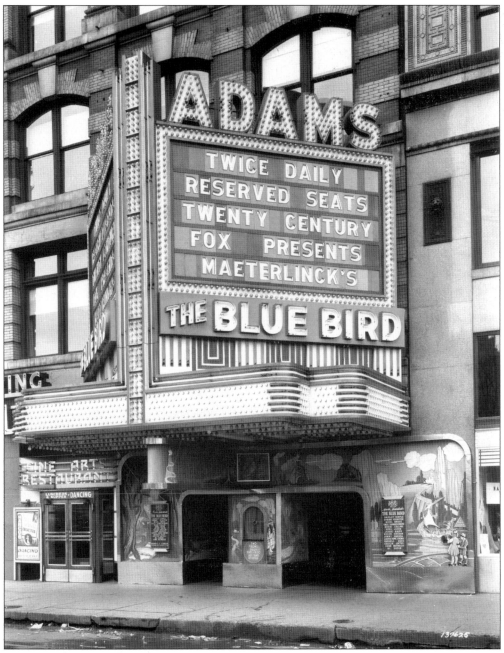

PREMIERES WERE NO STRANGER TO THE ADAMS THEATRE, 1940. The Adams hosted the Midwest premiere of 20th Century Fox's *The Blue Bird* starring Shirley Temple in 1940. Note the stylized attraction boards. Other major premieres included *Easter Parade* (1948), *Knights of the Round Table* (1953), *Kiss Me Kate* (1953), *Guys and Dolls* (1956), *Gigi* (1958), and *A Raisin in the Sun* (1961). The Adams was the first theater in Michigan to install MGM Camera 55 (70-millimeter process) in 1958 for *Raintree Country*. (Courtesy Manning Brothers Historical Collection.)

THE ADAMS SCREEN FLICKERS OUT, 1988. In 1963, Community Theaters purchased the Adams and modernized it to the tune of $250,000. The opening picture was *The Prize* with Paul Newman. First-run pictures flourished until the late 1970s, followed by a steady diet of action and horror pictures in the 1980s. The balcony was twinned in 1988; however, the theater closed later that year due to unruly patrons. (Courtesy Michael Hauser.)

ADAMS SPRUCED UP FOR THE SUPER BOWL, 2006. From 1992 to 1994, Preservation Wayne (Detroit's oldest and largest preservation organization) included the Adams as part of its annual downtown theater tour. Volunteers had cleaned the theater and replaced several hundred lightbulbs. The marquee was removed in 1999, as the theater continued to decay due to broken drainpipes, a leaky roof, and vandals. A temporary facade was installed in February 2006 by Ilitch Holdings, the current owner, to spruce up the property. (Courtesy Michael Hauser.)

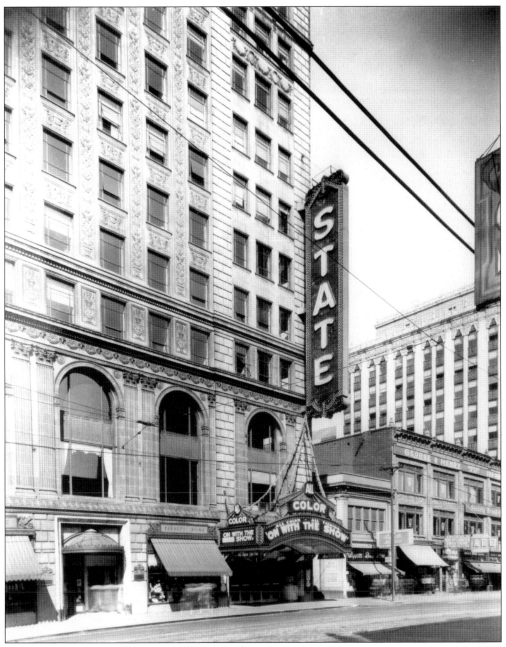

VIEW OF THE STATE THEATER, 1929. The $2 million State Theater was constructed in 1925 at 2111 Woodward Avenue on the site of the original Grand Circus Theater. It was built by the Francis Palms family in tribute to Francis, a Midwest real estate mogul in the 1800s. Built within a 12-story office structure, it was operated by John Kunsky. The spectacular blade sign measured 50 feet tall and 10 feet wide. (Courtesy Manning Brothers Historical Collection.)

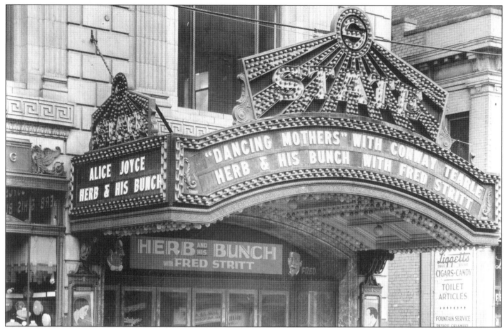

STATE MARQUEE, 1926. The first marquee was a cantilevered style with a sunburst lighting design. A hat store still occupied the space on the left, which later became an expanded lobby area. This was C. Howard Crane's fourth major commission in the Grand Circus Park Entertainment District. (Courtesy Manning Brothers Historical Collection.)

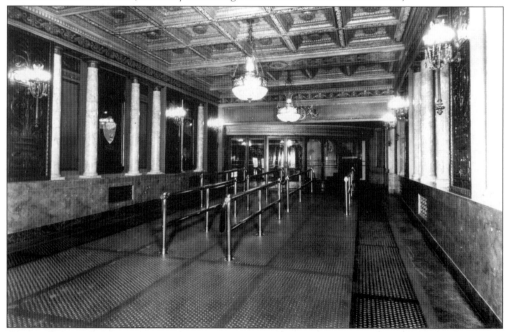

OUTER LOBBY, 1925. Once again, as was typical with theater entrances within office structures, the outer lobby was long and narrow. Note the detailed plaster ceilings, scagliola (faux marble) side columns, and the brass rails. As talking pictures took hold, the marquee signage proclaimed "the State Screen speaks!" (Courtesy Manning Brothers Historical Collection.)

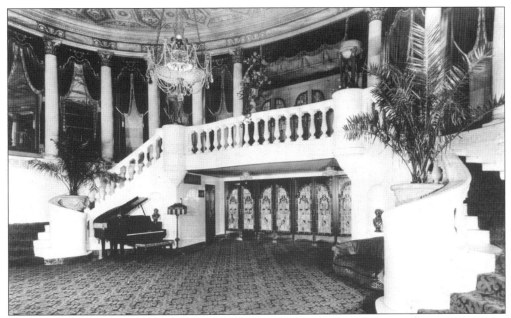

EXQUISITE ROTUNDA IN THE OUTER LOBBY, 1925. This is one of the most beautiful theater entrances in Detroit, featuring a marble horseshoe staircase, scagliola columns, rich draperies, stained-glass doors, chrome torchieres, and large potted palms. This lobby was designed to whisk patrons into another world, making them forget their worries. (Courtesy Manning Brothers Historical Collection.)

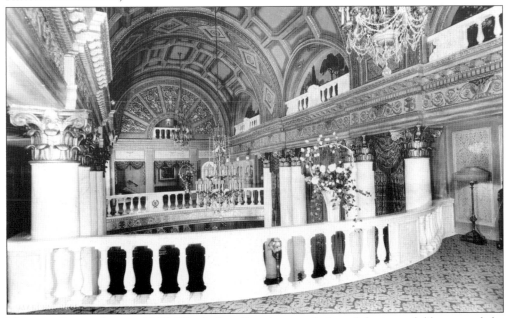

MAGICAL INNER LOBBY, 1925. The Italian Renaissance design of the inner lobby created the feeling of being in a European art museum. The barrel vaulted ceiling was augmented with oversized chandeliers, Corinthian columns with gilded capitals, marble banisters, murals, and fresh flowers. This was literally the "show before the show." (Courtesy Manning Brothers Historical Collection.)

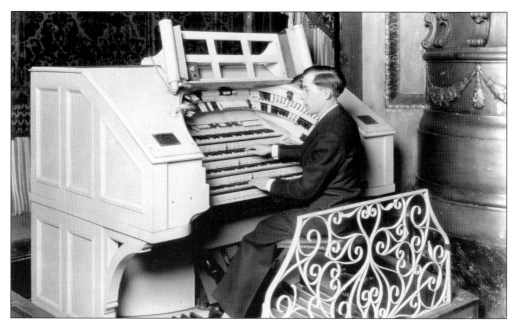

LEW BETTERLY AT THE STATE'S MIGHTY WURLITZER ORGAN, 1927. In addition to organ accompaniment for films, the State in the 1920s presented Loews Supreme vaudeville shows featuring the State Symphony Orchestra. The organ was removed many years ago, and today the console is housed in San Francisco's Castro Theater. (Courtesy Manning Brothers Historical Collection.)

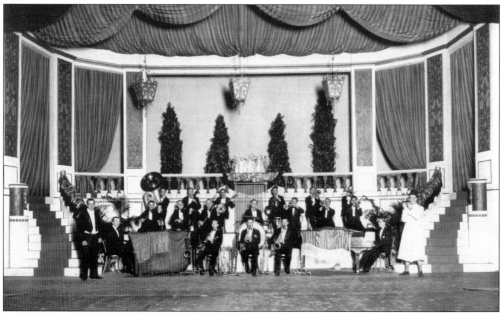

STATE STAGE PERFORMANCE, 1926. Stage shows were augmented with amateur vaudeville and films through the 1930s, with no advance in price. Admission was 30¢ until 6:30 p.m. The State introduced 10¢ parking in 1939 for patrons. In the late 1930s, the State became a "move over house" for the neighboring Michigan and United Artists Theaters before reverting back to first-run fare in 1942. (Courtesy Manning Brothers Historical Collection.)

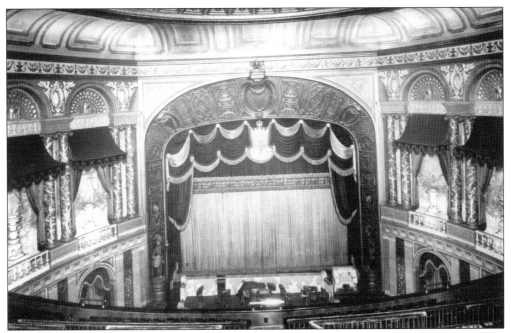

STATE AUDITORIUM AS SEEN FROM THE BALCONY, 1926. The auditorium initially contained 1,524 seats in the orchestra, 267 on the mezzanine, and 1,203 in the balcony. The original screen size was 20 by 24 feet, and the stage was 70 feet wide and 28 feet deep. Dressing rooms on multiple floors could accommodate 42 performers. (Courtesy Manning Brothers Historical Collection.)

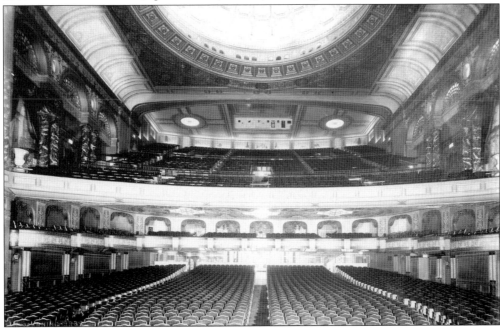

STATE AUDITORIUM AS SEEN FROM THE STAGE, 1926. The auditorium features a coffered ceiling dome, and the sidewalls are separated by paired Ionic columns and decorative urns. Garden scenes grace the walls in the balcony area, and gilded plaster statues of medieval knights flank each side of the stage. (Courtesy Manning Brothers Historical Collection.)

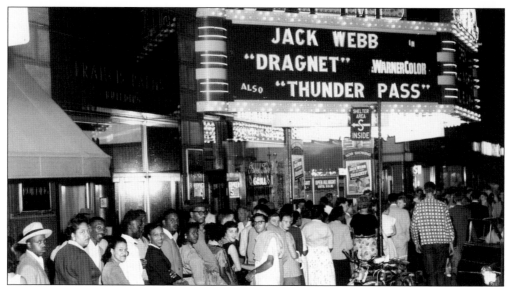

CROWDS LINED UP FOR WARNER BROTHERS' *DRAGNET*, 1954. The State had various name changes through the years: Palms State in 1937, Palms in 1949, and back to the State in 1979. Many film premieres have been held here through the years, including *It's a Wonderful Life* (1946), *Red River* (1948), *Rebel Without a Cause* (1955), and *Hatari* (1962). In the 1950s, the theater stayed open all night, and in 1960, *Psycho* played around the clock. In 1963, Alfred Hitchcock's *The Birds* shattered all house records. (Courtesy Central Business District Foundation.)

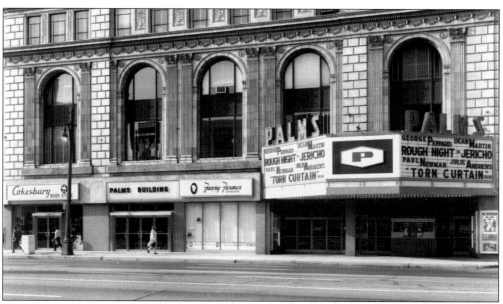

THE PALMS STATE, THE 1960S. Charles Forbes purchased the theater and adjoining office building in 1979 and has lovingly restored the facility for concerts and special events. In 1989, a $2 million investment converted the theater into Clubland. Since then, various club formats have been implemented, including the present Altered State. In 2003, Live Nation leased the theater for concerts and has since installed new seats and carpeting. Future plans call for additional restoration. (Courtesy Manning Brothers Historical Collection.)

Three

THE CAPITOL THEATRE

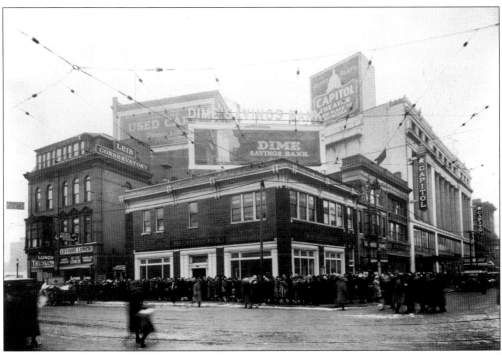

CROWDS LINE UP AT BROADWAY AND WITHERELL STREETS, 1926. In the 1920s, the Capitol Theatre prided itself on its stage shows and the popular Sunday Noon Symphony Concerts, featuring 75 musicians and artists on the stage. Eduard Werner was director of the Capitol Wonder Orchestra, and Robert G. Clarke played the Hilgreen Lane organ. The concert was included in the price of admission. This series became known as the "poor man's symphony." (Courtesy Manning Brothers Historical Collection.)

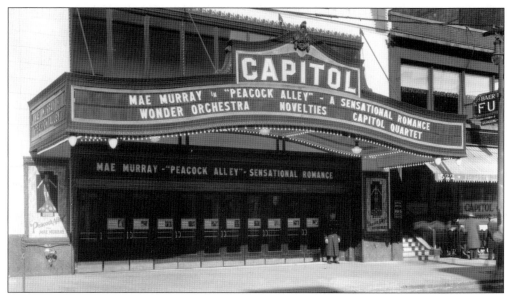

BROADWAY ENTRANCE TO THE CAPITOL, 1922. John Kunsky's $2 million Capitol, at 1526 Broadway, opened on January 12, 1922, and was the first theater designed in true "movie palace" style. Architect C. Howard Crane was inspired by European opera houses with his design for this Italian Renaissance venue, billed as "the showplace of Michigan!" The opening film was John Barrymore in *The Lotus Eater*, augmented with the Capitol's 40-piece Wonder Orchestra. (Courtesy Manning Brothers Historical Collection.)

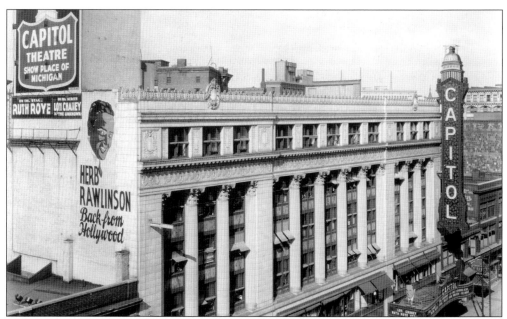

BROADWAY FACADE OF THE CAPITOL, 1927. The Broadway side of the theater featured glazed terra-cotta. Many of the icons found in decorative plaster inside the venue, such as griffins and rams' heads, are also present on the facade. In 1927, two smaller Capitol vertical signs were replaced with the six-story blade sign, visible from Grand Circus Park. (Courtesy Manning Brothers Historical Collection.)

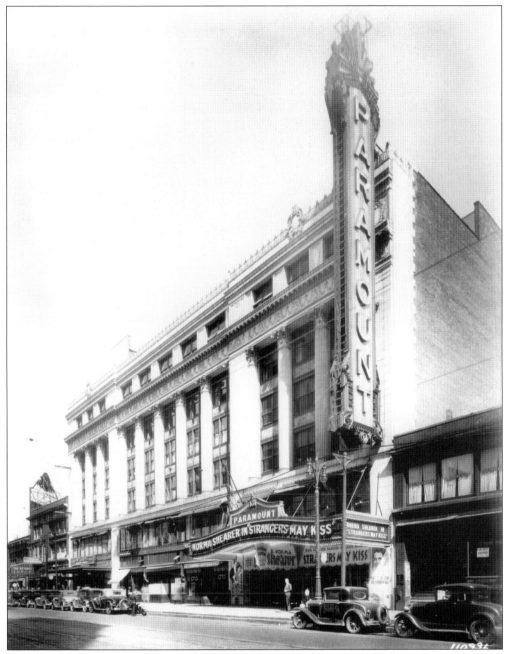

THE CAPITOL'S YEARS AS THE PARAMOUNT THEATRE, 1931. In 1929, John Kunsky sold the Capitol to Paramount Pictures, which changed the name and began scheduling the lavish Paramount Publix stage shows produced by John Murry Anderson. With the Great Depression looming, Paramount pulled the plug, and the theater closed in December 1932, sitting idle until United Detroit Theatres acquired the venue in 1934 and renamed it the Broadway Capitol. (Courtesy Manning Brothers Historical Collection.)

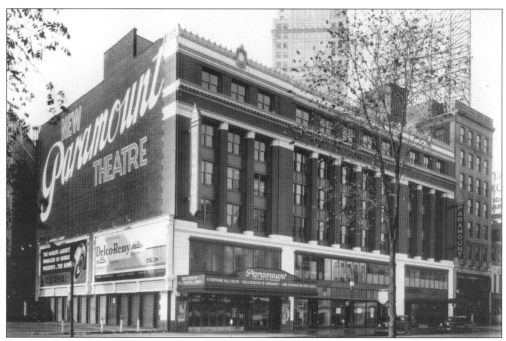

MADISON AVENUE FACADE OF THE PARAMOUNT, 1929. This side of the theater featured red brick and glazed terra-cotta trim. The marquee was more modest. Note the rooftop spectacular facing Grand Circus Park. Initially there was a secondary box office on Madison to handle the carriage trade patrons. (Courtesy Manning Brothers Historical Collection.)

COMMERCIAL TENANTS IN THE CAPITOL THEATRE BUILDING, 1940. The Capitol was augmented with six-story office structures on either side of the theater proper. If the theater failed, the owners would have rent from the various tenants to stabilize their investment in the property. Tenants included Krandall and Son Jewelers, Walsh College of Business, Roberts Furs, violin makers, tailors, beauty salons, a restaurant, and a bookstore—literally a city within a city! (Courtesy Manning Brothers Historical Collection.)

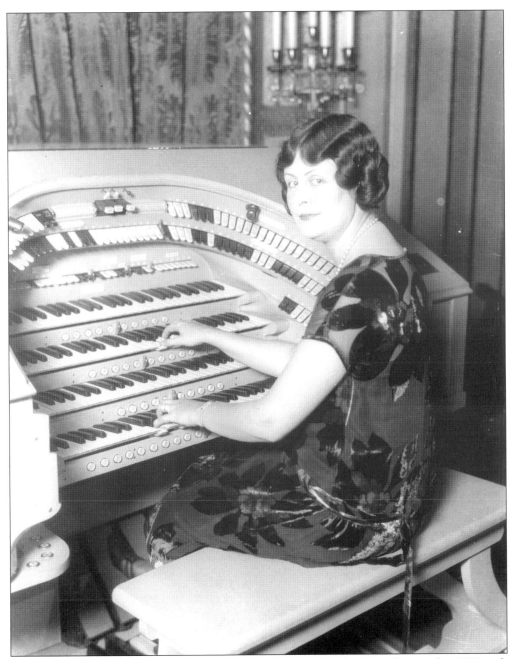

MARGUERITE WERNER AT THE MIGHTY WURLITZER, 1929. The Capitol opened in 1922 with a Hilgreen Lane organ. When Paramount acquired the venue, it felt this organ did not live up to the Paramount name and commissioned a Wurlitzer Publix 1 pipe organ for this theater. That mighty instrument remained until 1957, when it was moved to the Arcadia Ballroom. It then journeyed to a warehouse and finally found an appreciative home at the Paramount Theatre in Oakland, California. (Courtesy Walter P. Reuther Library, Wayne State University.)

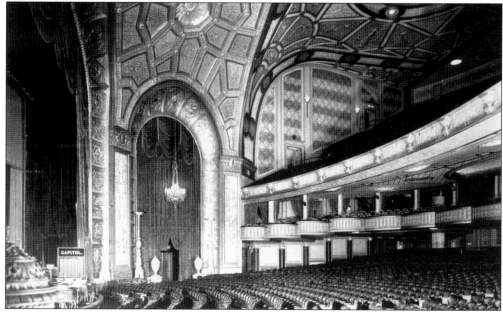

A View of the Capitol Auditorium from House Left, 1922. Various accounts have the seating capacity for the auditorium ranging from 3,300 seats to 4,250 seats. It was all about hype back then, and in some instances, even folding chairs and toilet seats were included in the count. This was one of the first large theaters constructed in North America with a clear span view with no column or pillar obstructions. (Courtesy Manning Brothers Historical Collection.)

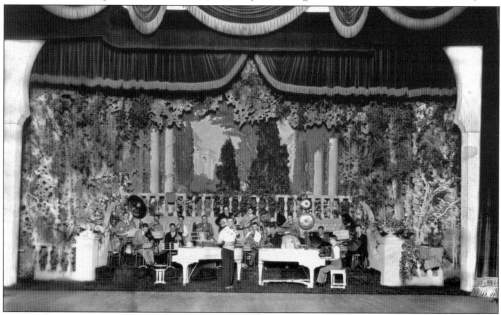

Stage Show at the Capitol, 1927. Besides the regular schedule of stage presentations, the Capitol also occasionally featured specials such as a chariot race on stage with live horses or an ice show. In the 1920s, there was also a large treadmill across the stage where, during the prologue, actors would convey the events of the day, which in Detroit's case included a fair amount of automotive news. (Courtesy Manning Brothers Historical Collection.)

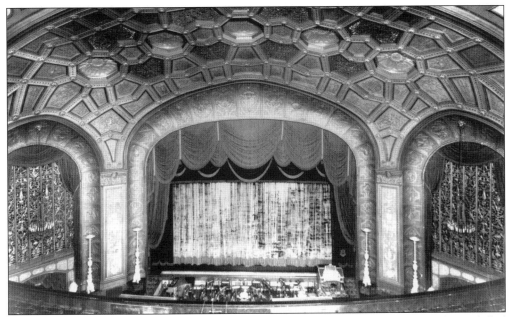

AUDITORIUM VIEW OF THE CAPITOL FROM THE BALCONY, 1929. The Capitol was billed as "the largest theater west of New York!" Original capacity included 1,766 orchestra seats, 281 mezzanine seats, and 1,386 balcony seats. The original screen was 20 by 24 feet, and the stage was 75 feet wide by 28 feet deep. The dressing rooms could accommodate 26 performers. (Courtesy Manning Brothers Historical Collection.)

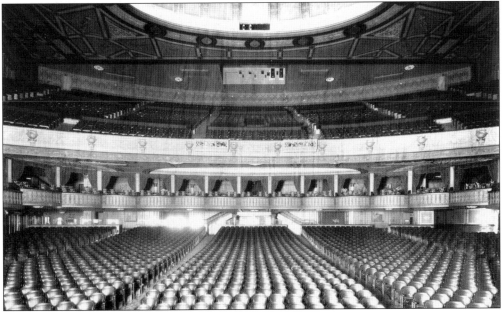

A VIEW OF THE AUDITORIUM FROM THE STAGE, 1929. The large plaster oval in the ceiling, painted in blue and gold, signified the sky during the movie palace era. This oval space, accessed by a catwalk system, was ringed with 3,000 pink, blue, and yellow lightbulbs. There is actually another floor of space above the ceiling as it is all suspended from the roof. (Courtesy Manning Brothers Historical Collection.)

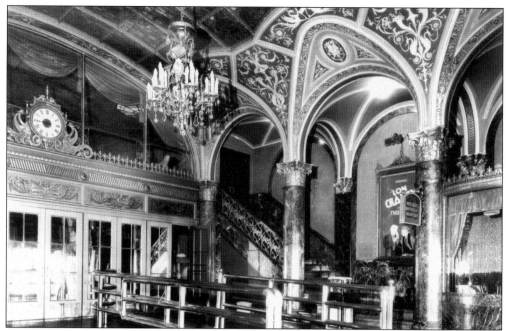

OUTER LOBBY ON BROADWAY, 1929. This lobby, incorporating the box office, has always been the main entrance. From the 1920s through the 1940s, most patrons arrived via several streetcar lines that stopped at the front door. Later most patrons arrived by automobile or bus. This lobby featured a backlit stained-glass ceiling, marble, decorative plaster, and brass. (Courtesy Manning Brothers Historical Collection.)

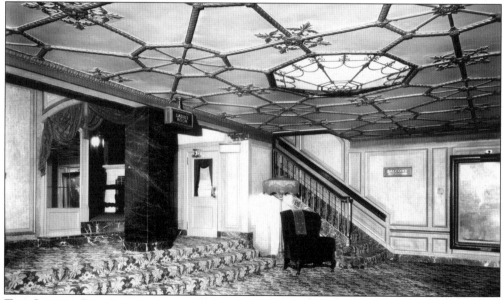

THE CAPITOL BOX LEVEL, 1922. The box level featured 17 boxes, each containing 12 seats. Heavy green draperies hanging from large brass rods provided privacy for these patrons. The ceiling on this level was adorned with large milk glass light fixtures, and furnishings on this level included decorative lamps, oil paintings, and lounge chairs. (Courtesy Manning Brothers Historical Collection.)

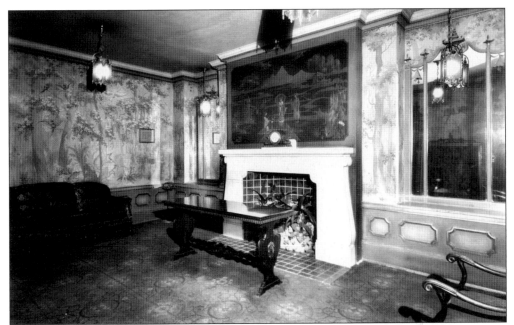

LADIES' POWDER ROOM, 1922. Unlike the rest of the Italian Renaissance style of the theater, the ladies' powder room, located on the north end of the box level, was designed in an Asian motif. It was adorned with wall tapestries, lanterns, and pagodas atop the two large mirrors and was augmented with a beautiful fireplace. (Courtesy Manning Brothers Historical Collection.)

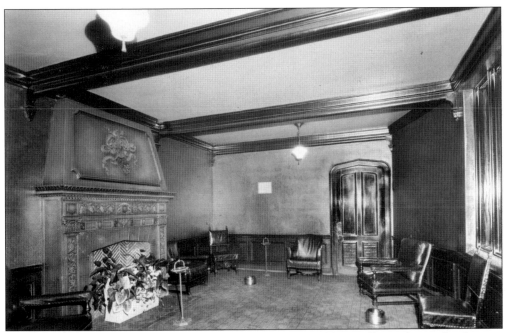

GENTLEMAN'S SMOKING LOUNGE, 1922. Yes, patrons could actually smoke in this lounge, located on the lower level of the theater, beneath the grand staircase. This room had a club room feel to it with a decorative fireplace, leaded glass windows, and leather chairs. Note the ashtrays and the spittoons. (Courtesy Manning Brothers Historical Collection.)

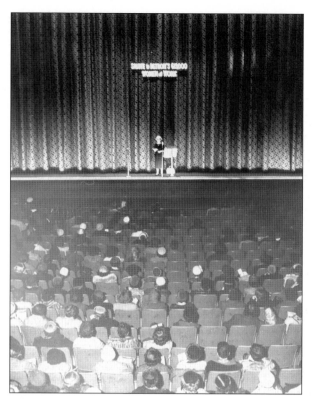

SPECIAL EVENT, 1954. The auditorium fills up for the Central Business District Association's annual Salute to Women Who Work!. This annual event rotated among the downtown theaters. The program encompassed speakers, a fashion show, and a luncheon, all designed to highlight the importance of women in Detroit's workforce. (Courtesy Central Business District Foundation.)

UNITED DETROIT THEATRES EVENT, 1963. The phenomenal success of Downtown Detroit Days in the many stores downtown also caught the eye of the theater owners. United Detroit Theatres participated in many of the retail promotions, as well as the beloved "mystery shopper" promotion, which provided downtown guests with free movie passes. (Courtesy Central Business District Foundation.)

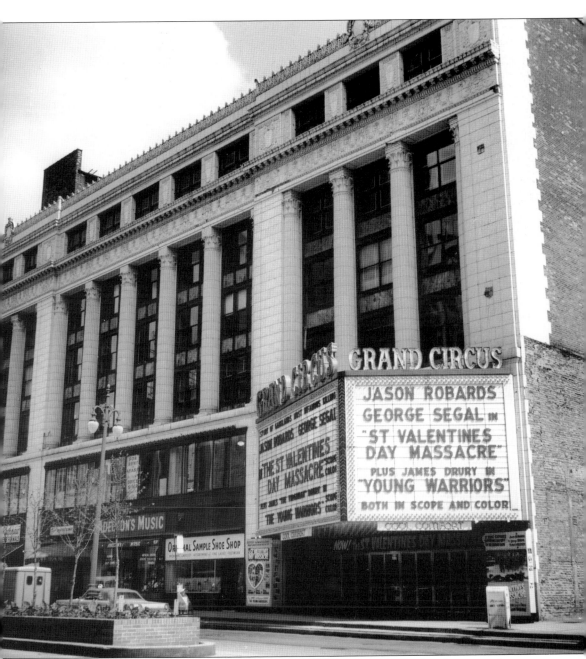

GRAND CIRCUS THEATER MARQUEE, 1967. In the autumn of 1960, this theater underwent a $250,000 renovation and was rechristened the Grand Circus Theater by United Detroit Theatres. Besides reducing the seating to 1,400, 70-millimeter projectors were added, a new 54-foot screen was installed, and an immense V-shaped marquee was added. The gala reopening featured the Michigan premiere of *The World of Susie Wong*. (Courtesy Theatre Historical Society of America, Elmhurst, Illinois.)

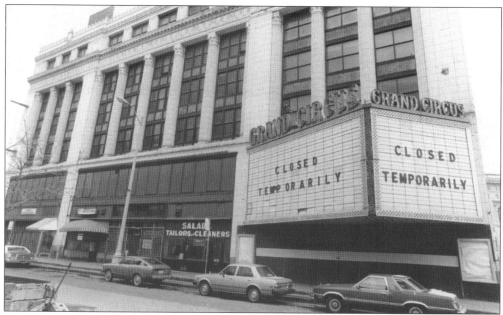

REALITY CHECK, 1978. After serving the public for over 50 years with programming that ranged from films to stage shows, jazz, opera, and live broadcasts, time was gradually running out for this venue. By the 1970s, the doors stayed open by showcasing horror, gore, kung fu, and soft-core pornography. The final bill in November 1978 was *Jailbait Babysitter* and *The Naked Rider*. (Courtesy Walter P. Reuther Library, Wayne State University.)

NOT LIVING UP TO THE HYPE. It was less expensive to close the doors of this venue, rather than stay open, and so from 1978 to 1980, it remained closed. From 1980 to 1984, it came to life as a rock concert palace, Grand Circus Live!, featuring acts like Grace Jones, the B-52's, and Motorhead. The crowds were not kind to the building, resulting in theft and damage, and the owners walked away from the venue in the autumn of 1984. (Courtesy Michael Hauser.)

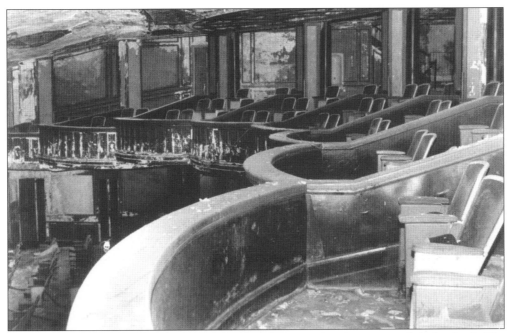

BOX LEVEL DAMAGE, 1988. From 1984 through 1988, the theater was left for dead. The water had not been turned off in the winter of 1984, resulting in frozen pipes that burst and subsequently flooded and damaged the theater. The facility was not secured and became a haven for scavengers and street people seeking shelter. (Courtesy Cristina DiChiera.)

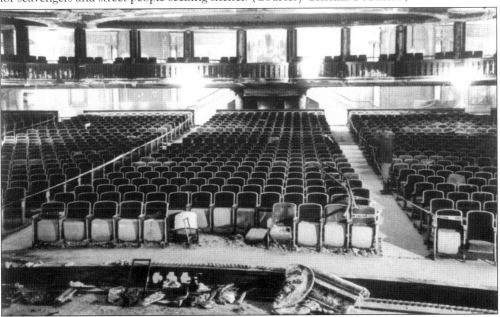

AUDITORIUM IN SHAMBLES, 1988. Despite the horrendous conditions, Dr. David DiChiera, general director of Michigan Opera Theatre, had a vision for this venue and that was to restore it as the new home for the opera company. Michigan Opera Theatre acquired the facility in 1989, and after much blood, sweat, tears, and several capital campaigns, it reopened this amazing venue as the Detroit Opera House in April 1996. (Courtesy Cristina DiChiera.)

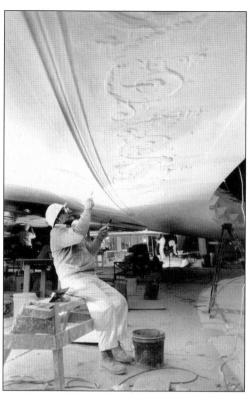

PLASTER RESTORATION ARTISTS, 1995. Since the theater had been abandoned for four years, with no heat or air, and snow and rain pouring in from the threadbare roof, a great deal of the decorative plaster was destroyed. A team of plaster restoration artists spent over a year re-creating the auditorium ceiling, the proscenium arch, and various ornamental icons throughout the facility. (Courtesy Michigan Opera Theatre.)

DECORATIVE PAINTING, 2002. Roumen Boudev re-created frescoes in one of the third-floor oval lobbies of the theater. Additional murals in the grand lobby were re-created on canvas and then reapplied to the walls. Michigan Opera Theatre worked with Steve Seebohm, who performed over 800 testings throughout the facility to determine the original color pigmentations for the historic decorative painting phase of the restoration. (Courtesy Michael Hauser.)

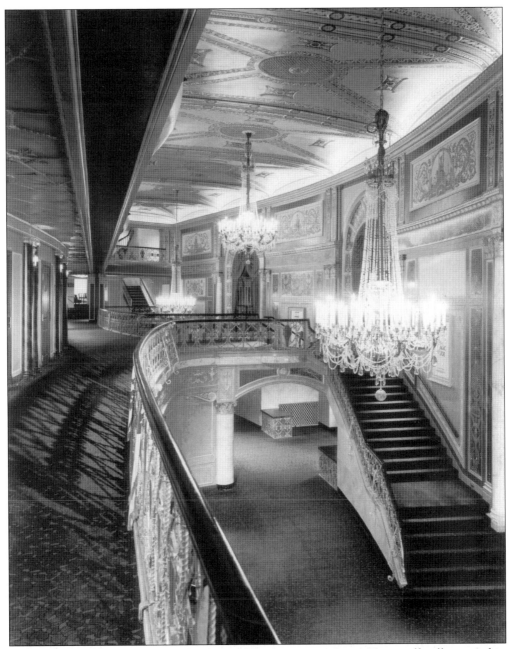

RESTORED GRAND LOBBY, 1998. Even though the Detroit Opera House officially opened in 1996, funding was not available for completing the grand lobby until a generous anonymous donation was received in 1998. Once again, the crystal chandeliers are ablaze, the decorative plaster and railings have been repaired, the murals are back in place, and the glorious decorative paint colors of gold, blue, green, and rose provide a warm welcome for patrons. (Courtesy Albert Kahn Architects.)

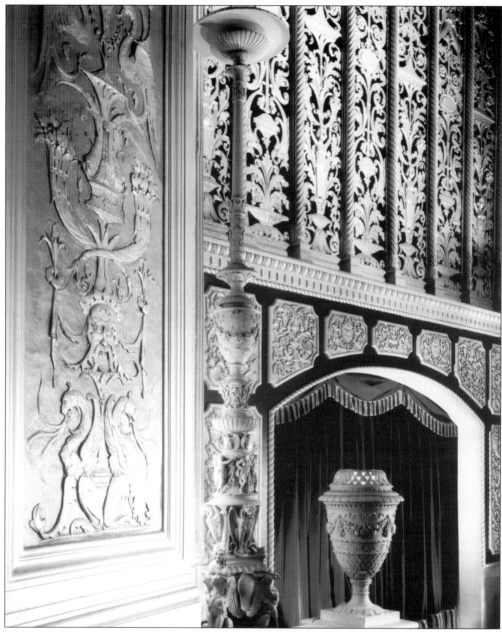

RESTORED AUDITORIUM, 1998. Since reopening the theater in 1996, Michigan Opera Theatre has continued to restore this amazing facility in segments. Decorative painting in the auditorium was completed in 2004, and in 2006, the six floors of offices and former shops on the Broadway side of the theater reopened as the Ford Center for Arts and Learning. (Courtesy Albert Kahn Architects.)

Four

THE MICHIGAN THEATRE

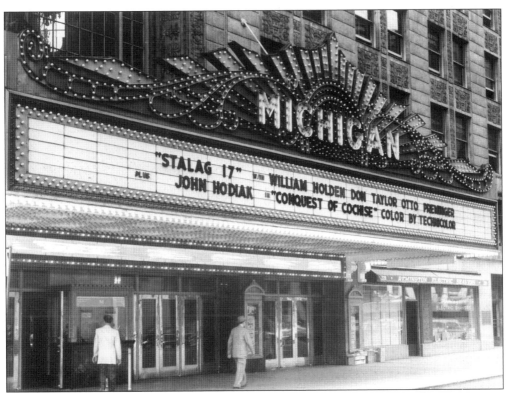

THE MIGHTY MICHIGAN THEATRE, 1953. When this massive theater opened in 1926, many wondered if it could live up to all the media hype. The *Detroit Times* declared, "The Michigan is a promise fulfilled! A spacious playhouse to meet the importance of a wonderful city!" The *Detroit Free Press* harked, "It is beyond the human dreams of loveliness, rising in mountainous splendor!" Today audiences are in awe of the faded glory of this once magnificent palace, as they see the Michigan in a new light, as the occasional "star" of films and music videos. (Courtesy Central Business District Foundation.)

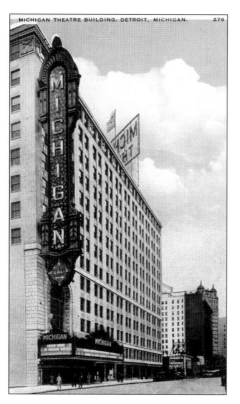

HISTORIC POSTCARD VIEW OF THE BLADE SIGN. The 10-story-high blade sign at the Michigan was one of the largest vertical signs ever constructed for a movie palace. It served as a beacon for those traveling downtown on the Grand River streetcars and later in automobiles. It was declared a nuisance by the City of Detroit in 1952 and was removed. (Courtesy Michael Hauser.)

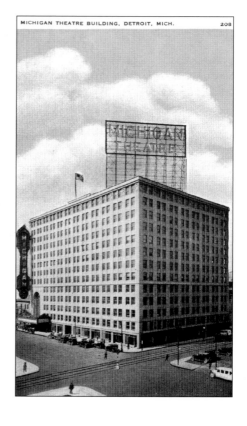

HISTORIC POSTCARD VIEW OF THE ROOFTOP SPECTACULAR. This view is looking west on Bagley Street. The giant rooftop spectacular measured 85 feet tall and 34 feet wide. At one time, the words "office building" were also emblazed at the bottom of the sign. (Courtesy Michael Hauser.)

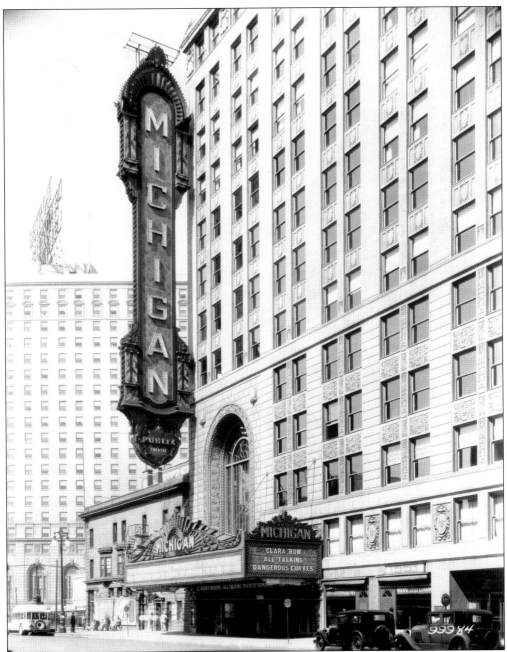

IMPRESSIVE MICHIGAN ENTRANCE ON BAGLEY STREET. This view looking west on Bagley Street shows the perspective of the massive 10-story-high blade sign. The main floor featured several shops and a restaurant. A fleur-de-lis pattern is featured on the exterior of the building as well as in plaster detail in the lobby. The Leland House Hotel in the background was also designed by the C. W. and George L. Rapp, the architects for the Michigan. (Courtesy Manning Brothers Historical Collection.)

MIDDLE STREET EXIT. These doors, on the Middle Street side of the theater, were primarily used for exiting the throngs who flocked to the Michigan. Note the faux arched window, with no ornamentation, that replicates the detailed version facing Bagley Street that is mirrored and lit. (Courtesy Manning Brothers Historical Collection.)

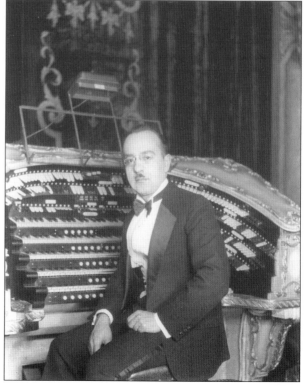

HOUSE ORGANIST ARTHUR GUTOW, 1927. The mighty Michigan five-manual Wurlitzer pipe organ was the first of three ever manufactured. This fascinating instrument was not used after 1936. In 1955, Fred Hermes purchased the organ for $1,000 and moved it the next year to his home in Racine, Wisconsin, where it is still producing amazing melodies. (Courtesy Manning Brothers Historical Collection.)

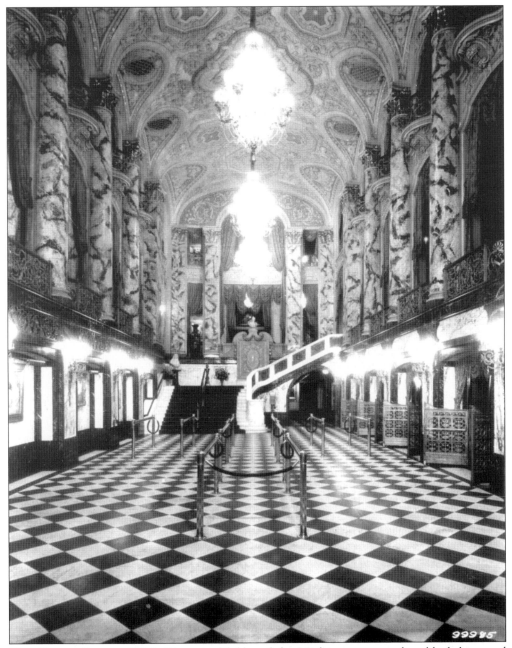

THE GRAND LOBBY, 1926. The grand lobby of the Michigan was nearly a block long and five stories high. Competing with brass, marble, and decorative paint were four immense crystal chandeliers. Each of these stunning light fixtures weighed 2,500 pounds and contained 210 lightbulbs. In later years, once the theater closed for good, the chandeliers were sold at auction. (Courtesy Manning Brothers Historical Collection.)

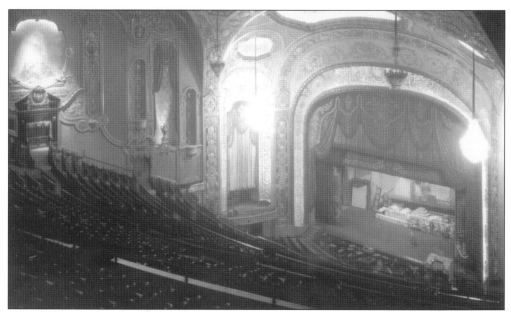

AUDITORIUM AS SEEN FROM THE BALCONY. The Michigan was designed in a French Renaissance style by well-known Chicago architects C. W. and George L. Rapp. Opening day was August 23, 1926. It took two years to construct this $3.5 million edifice. Initially this theater was operated jointly by B and K Theaters and John Kunsky. In 1933, it was acquired by United Detroit Theatres. (Courtesy Walter P. Reuther Library, Wayne State University.)

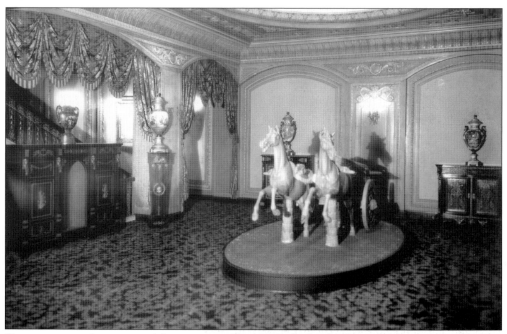

CORRIDORS OF ARTIFACTS. Many patrons felt as though they had entered an art museum once they began to explore the inner depths of the Michigan. Innumerable precious art objects and paintings adorned walls, alcoves, and corridors. The art was augmented with furnishings and lavish draperies and tapestries. (Courtesy Walter P. Reuther Library, Wayne State University.)

AUDITORIUM SIDEWALL DETAIL.
The original seating capacity for the Michigan consisted of 1,981 orchestra seats, 224 mezzanine seats, 1,488 balcony seats, 312 loge seats, and 34 box seats. The screen size was 21 feet by 18 feet, and the stage dimensions were 75 feet wide by 35 feet deep. (Courtesy Walter P. Reuther Library, Wayne State University.)

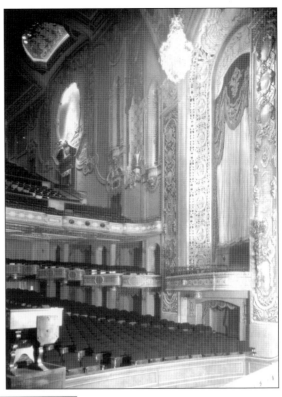

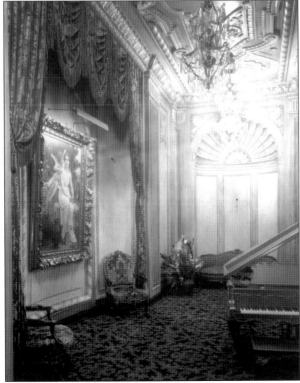

AN ABUNDANCE OF DECOR.
Visual distractions abounded throughout the theater and included carved balustrades, marble staircases, and a variety of art objects. The Michigan's art collection included oil paintings from the National Academy, an array of Sevres sculptures, an unusual collection of pedestals, and an Empire Suite of furniture. (Courtesy Walter P. Reuther Library, Wayne State University.)

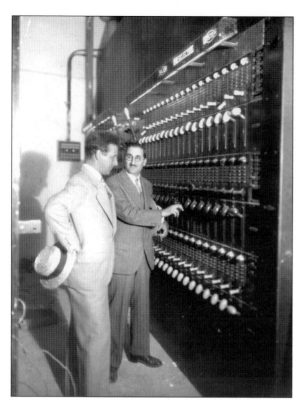

BACKSTAGE AT THE LIGHT BOARD CONTROLS. The electric switchboard was operated by two master electricians. This elaborate mechanism featured 6,500 combinations of colors and various intensities of light. At the time, the Michigan also had the world's largest theater refrigeration plant that washed, dried, cleansed, and tempered to the proper degree a complete new supply of air every 96 seconds. (Courtesy Walter P. Reuther Library, Wayne State University.)

CHIEF OF SERVICE AT YOUR CALL, 1943. George McCann was chief of service at the Michigan in the 1940s. He was responsible for a staff that included up to 200 ushers. The 1940s featured many big bands that played on the Michigan stage: Frankie Carle Orchestra, the Woody Herman Orchestra, Jimmy Dorsey and his band, Spike Jones, Harry James, Vaughn Monroe, and Glenn Miller. (Courtesy George McCann.)

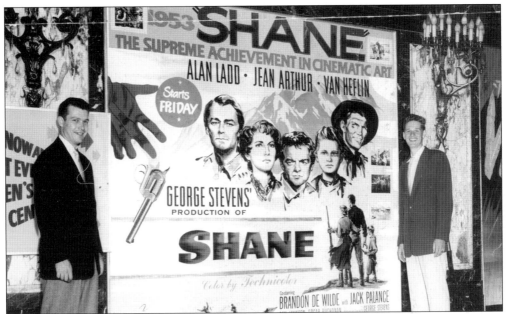

MICHIGAN PREMIERE OF SHANE, 1953. With the Michigan as United Detroit Theatres' flagship house, it was Shan Sayles's (standing on right) job as marketing manager to set up premieres and hoopla that included the visiting stars. Notable appearances in the 1950s included Betty Hutton (*Let's Dance!*), Gloria Swanson (*Sunset Boulevard*), Burt Lancaster (*The Flame and the Arrow*), Joan Crawford (*Queen Bee*), and Rock Hudson (*Pillow Talk*). (Courtesy Shan Sayles.)

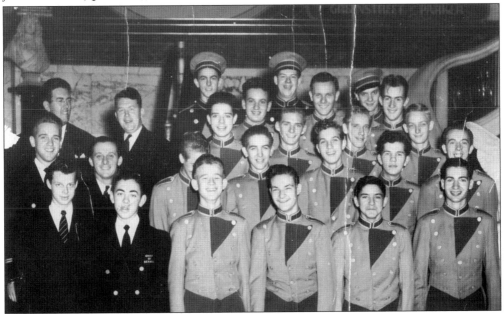

MICHIGAN USHER STAFF, 1944. The staff at the Michigan was prepared for many forms of entertainment, from the advent of talking pictures to vaudeville, big bands, lavish Publix stage shows, traveling Broadway shows, an ice show, and 3-D pictures. It was the first theater in the state to install Vista Vision, for *White Christmas* in 1953. Records were smashed through the years by such films as *House of Wax*, *Flower Drum Song*, and *Gypsy*. (Courtesy George McCann.)

FALL FASHION FESTIVAL, 1959. Besides hosting film premieres, the Michigan was used as a special events venue. The image above depicts a fashion show staged by the Central Business District Association. Other events included management meetings by the J. L. Hudson Company Department Store and big-screen telecasts of boxing matches and University of Michigan football. (Courtesy Central Business District Foundation.)

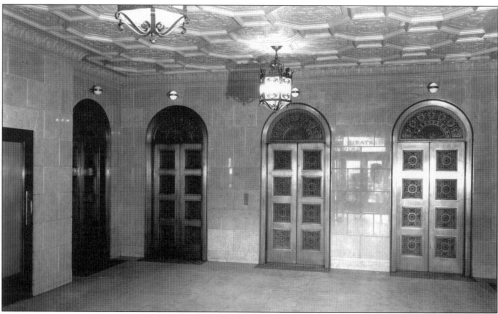

MICHIGAN OFFICE BUILDING ENTRANCE ON BAGLEY STREET, 1927. Today's office building lobby resembles the image above. The detailed plaster ceiling was never covered with a drop-leaf ceiling, and the marble walls are still there as are the light fixtures. The brass elevator doors are as resplendent as ever, although the elevator cabs were modernized and automated some years ago. (Courtesy Manning Brothers Historical Collection.)

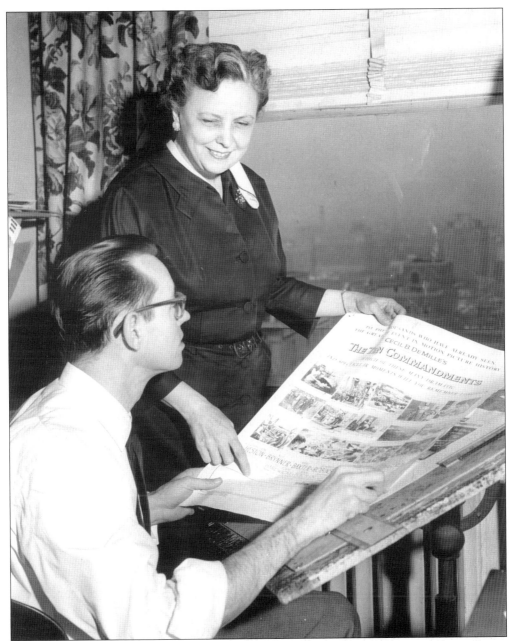

ALICE GORHAM, DETROIT'S GURU OF FILM PUBLICITY, 1957. Alice Gorham joined powerhouse United Detroit Theatres in 1934 and by 1939 was its director of public relations and advertising, a post she held until her unexpected death in 1957. As one of the highest-ranking females in the film industry, Gorham had a keen sense for promotion and created many memorable headlines for motion pictures. (Courtesy Central Business District Foundation.)

TIME RUNS OUT FOR THE MICHIGAN.
With declining patronage, rising costs, and difficulty in securing films, United Detroit closed the Michigan in March 1967. Later that year, rival Nicholas George Theaters leased the theater, made some renovations, and reopened that Christmas with 20th Century Fox's *Valley of the Dolls*. George tried everything to stem the losses, even briefly reviving stage shows and hosting rock concerts, but the handwriting was on the wall, and once again the theater closed, in 1970. (Courtesy Michael Hauser.)

LITERALLY THE WORLD'S ONLY "TRUE" DRIVE-IN THEATER. Christmas 1970 saw another short reprieve with RGW Enterprises reopening this palatial venue. In 1972, restaurateur Sam Hadous rechristened the theater as the Michigan Palace, a supper club with top-name acts. By year's end, he closed the venue in debt. In 1974, the theater reinvented itself as a rock concert palace, which closed in 1975 over a rent dispute. In 1977, the theater was gutted in a $525,000 conversion to a three-story parking garage. (Courtesy Michael Hauser.)

Five

THE FABULOUS
FOX THEATRE

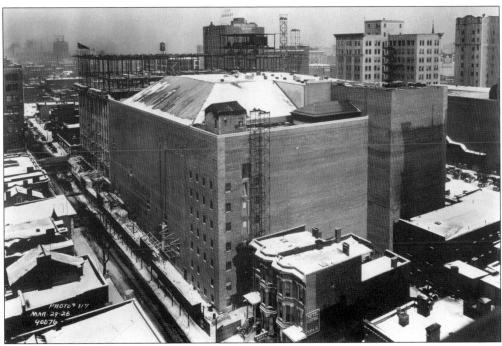

FOX THEATRE CONSTRUCTION PROGRESSES, 1928. William Fox, founder of 20th Century Fox Studios, began construction of Detroit's 5,000-seat Fox Theatre in March 1927. The theater opened 18 months later on September 21, 1928, at a cost of over $6 million. The Detroit Fox was a model for an identical St. Louis Fox that was built almost simultaneously. This view is from the corner of Montcalm Street and Park Avenue, looking east. (Courtesy Manning Brothers Historical Collection.)

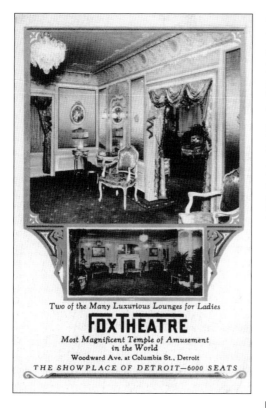

VINTAGE POSTCARD OF LADIES' POWDER ROOM, 1928. William Fox's shrewd marketing efforts to heighten awareness of his "temple of amusement" included the distribution of postcards such as these. The unique interior of the Fox Theatre is "Siamese-Byzantine," which is a combination of Far Eastern, Egyptian, Babylonian, and Indian themes from around the world. William Fox dubbed this style the "Eve Leo Fox Style," in tribute to his wife who traveled the globe acquiring furnishings, artifacts, and paintings to appoint the theater. (Courtesy Michael Hauser.)

VINTAGE POSTCARD OF THE GRAND LOBBY, 1928. The grand lobby was designed to resemble an Indian temple, with rows of faux marble (scagliola) columns enveloping this magnificent space. The terrazzo lobby floor was originally covered with one the largest wool rugs ever manufactured in the United States. The Indo-Chinese design was three-fourths of an inch thick and covered 3,600 square feet of floor space. (Courtesy Michael Hauser.)

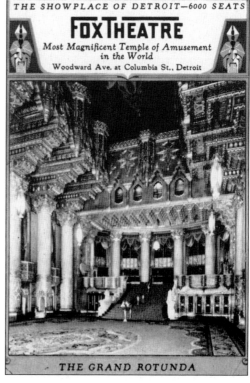

VINTAGE POSTCARD OF FOX BUILDING, 1929.
This artist interpretation of the Fox Theatre depicts an eight-story blade sign and a modest box-style marquee at 2211 Woodward Avenue. Architect C. Howard Crane designed the Fox in a style referred to as "Picture Palace Gothic," demonstrating his unique style of mixing movie glitz with Old World elegance. (Courtesy Michael Hauser.)

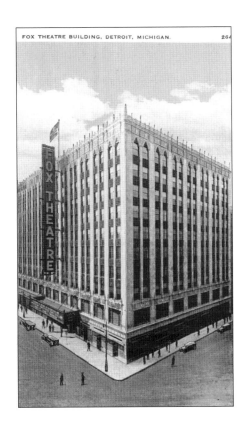

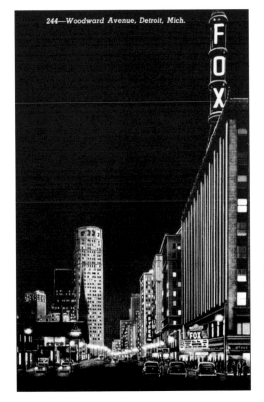

244—Woodward Avenue, Detroit, Mich.

VINTAGE POSTCARD, LATE 1940s. This rendering represents a more streamlined look at the Fox's exterior, with a rooftop sign and a triple-sided marquee. Architect C. Howard Crane's Fox Theatre was considered the most beautiful of the 52 theaters he designed in the Detroit area. Crane's versatile side was also demonstrated with his design for Detroit's Olympia Stadium (demolished) and the Film Exchange Building on Cass Avenue, behind the Fox. (Courtesy Michael Hauser.)

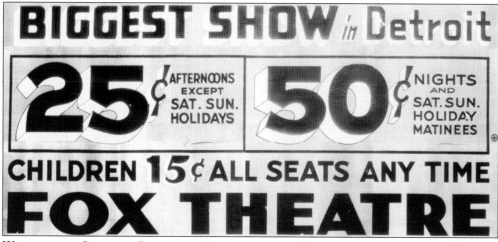

WALKER AND COMPANY BILLBOARD HERALDING THE FOX, 1930. It is unimaginable today that for the prices noted above one could enjoy not only a film but a full stage show. A typical "show" included the Fox Grand Orchestra, a Fanchon and Marco–scripted stage production, and dancing from the Tillerettes, 32 precision dancers modeled after the Radio City Rockettes. (Courtesy Burton Historical Collection, Detroit Public Library.)

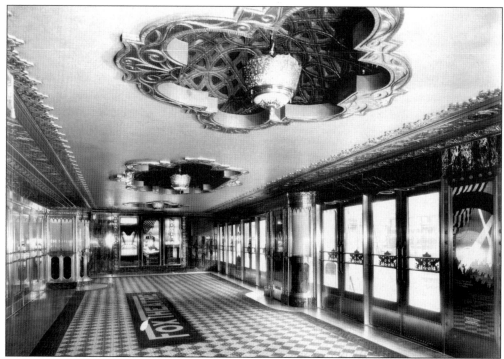

FOX STORM LOBBY, 1928. At the Fox, "the show" really did begin on the sidewalk, beneath the emblazoned letters under the marquee that heralded "Detroit's Finest Entertainment!" The storm lobby was accented with a dozen brass doors and two brass box offices. Rich pastel colors and intricate plaster moldings provided but a hint of the luxurious atmosphere to be found behind the second set of brass doors. (Courtesy Manning Brothers Historical Collection.)

FOX THEATRE PLAYBILL, 1928. The opening film at the Fox was 20th Century Fox's *Street Angel* starring Janet Gaynor and Charles Farrell. The program also included Fox Movietone News, playwright George Bernard Shaw, the 60-member Fox Grand Orchestra under the direction of Adolphe Kornspan, a 50-voice chorus, the Tillerettes, and an eight-episode pageant entitled "The Evolution of Transportation," visualizing Detroit's industrial progress. (Courtesy Michael Hauser.)

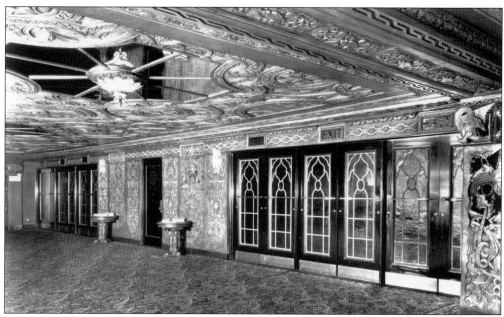

FOX INNER LOBBY, 1928. Through the leaded glass doors, trimmed in brass and encased in walnut, lies the inner lobby. Lush red velvet, ceiling mirrors, gold braid, intricate wrought iron, glowing wall sconces, and plaster images abound. The expanse of this lobby, as well as the auditorium, is covered with the theater's elephant-patterned carpeting. (Courtesy Manning Brothers Historical Collection.)

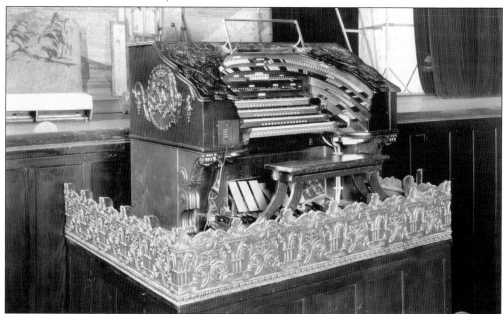

THE MIGHTY WURLITZER, 1928. The Detroit Fox is one of only a handful of theaters in Michigan to still house its original pipe organ. This Wurlitzer is the second-largest pipe organ ever manufactured by that company and is one of only five built for William Fox's theater empire. Built at a cost of over $100,000, this massive instrument contains almost 3,000 pipes and requires seven chambers to house them. (Courtesy Manning Brothers Historical Collection.)

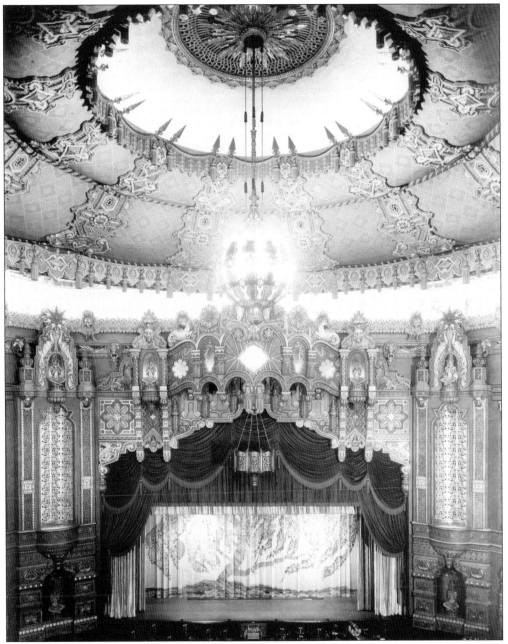

MAGNIFICENT AUDITORIUM VIEW, 1928. The auditorium ceiling is 105 feet high and was designed to represent an Arabian tent. A giant sunburst shines in a blue sky through an opening at the pinnacle, and hand-stenciled canvas panels intermix with plasterwork and are speckled with thousands of glass "jewels." Suspended from the ceiling is a glass chandelier that weighs two tons, requires 200 lightbulbs, and contains 1,240 individual pieces of leaded glass. (Courtesy Manning Brothers Historical Collection.)

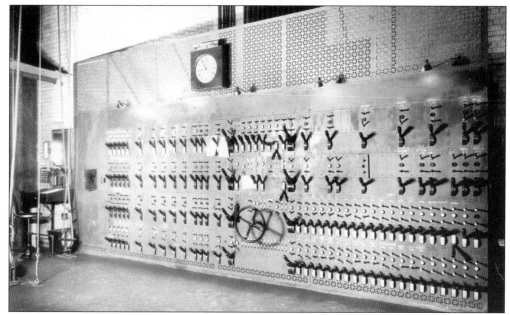

LIGHT BOARD AT THE FOX, 1928. This image depicts the intricate light board, located near the front of the stage. The lights that flooded the cyclorama curtain could create a feeling of infinite space for awesome sunrises, sunsets, or any other natural effects. This board also controlled the various ceiling and cove lights that bathed the auditorium in various moods of color. (Courtesy Manning Brothers Historical Collection.)

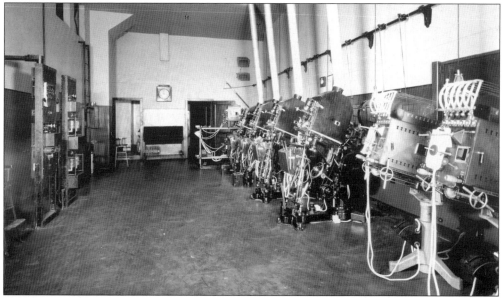

THE WORLD'S LARGEST PROJECTION BOOTH, 1928. The dimensions for this booth were 35 feet wide, 20 feet deep, and 18 feet high. Besides motion picture projectors, this room contained follow spots and effects projectors. Today's booth is equipped for both 35-millimeter and 70-millimeter projection. Additionally, William Fox had a private screening room on the lower level of the theater that was adorned with murals of some of 20th Century Fox's leading stars. (Courtesy Manning Brothers Historical Collection.)

DRESSING ROOMS, 1928. Performers and musicians were accommodated with 21 dressing rooms spread out over eight floors of the stage house. Most of these dressing rooms were functional at best, certainly not lavish. Note the side pouches on the chairs in the image above for easy storage of shoes. (Courtesy Manning Brothers Historical Collection.)

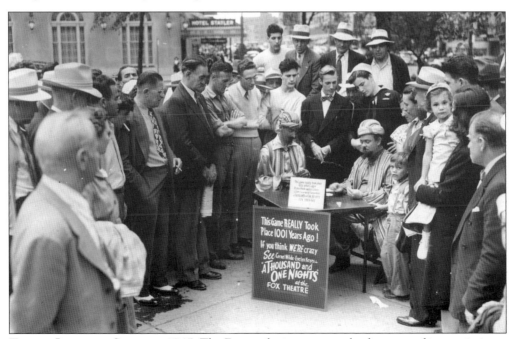

TAKING IT TO THE STREETS, 1945. The Fox marketing team took advantage of its proximity to the many hotels and offices surrounding Grand Circus Park to literally "set up shop" in the park to promote upcoming films. It would not take long for an eager crowd to gather and partake in a film-related promotion. (Courtesy Fox Theatre Archives.)

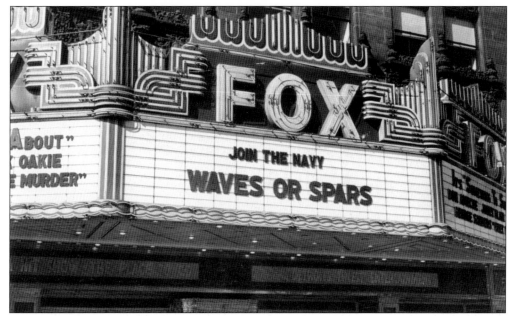

THE FOX DURING THE WAR YEARS. When the U.S. government commissioned movie theaters to sell war bonds, exhibitors responded with elaborate banners, lobby displays, and numerous promotions, all designed to encourage public participation. War bond "premieres," also known as "victory shows," were a highly successful way to promote the sale of war bonds. (Courtesy Fox Theatre Archives.)

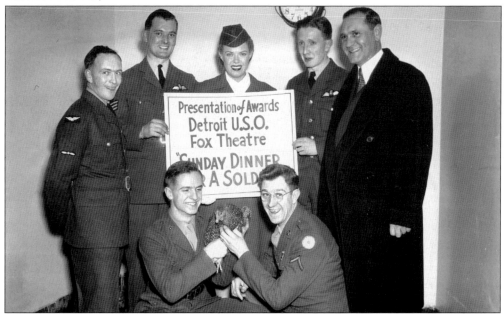

USO AND WAR BOND SHOWS AT THE FOX, 1944. Patriotic ceremonies were conducted on stage prior to a film, for special wartime matinees. USO officials, local civic leaders, and military personnel would lead the ceremonies with a flag presentation, the Pledge of Allegiance, and a tribute to Gen. Douglas MacArthur. Movie attendance during the war years soared to record levels. (Courtesy Fox Theatre Archives.)

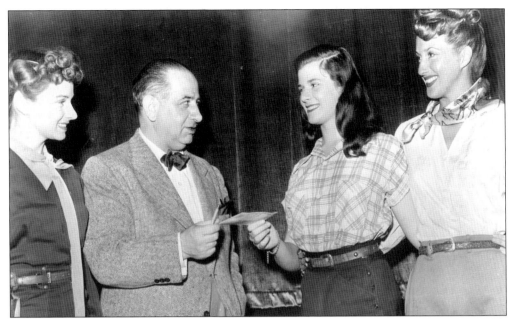

PROMOTING FRONTIER GAL AT THE FOX, 1945. To promote this film (starring Yvonne De Carlo), Fox manager David Idzal offered free admission to anyone who arrived to the show on horseback. The management erected a 50-foot hitching rail on busy Woodward Avenue. More than 30 horses appeared, and their riders put on a brief rodeo show. (Courtesy Fox Theatre Archives.)

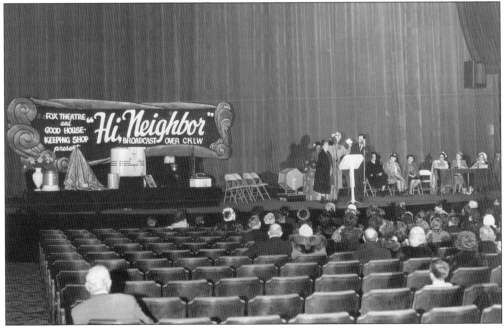

LIVE RADIO BROADCASTS FROM THE STAGE. This image depicts a 1940s CKLW Radio broadcast from the Fox stage in partnership with downtown's Good Housekeeping Shop. Other memorable radio broadcasts include the cast of WJR Radio's *Hermit's Cave* program in the 1930s and Ralph Edwards's *Truth or Consequences* in the 1940s. (Courtesy Fox Theatre Archives.)

STAR-STUDDED PREMIERE, 1946. The Fox was the Midwest premier showcase for 20th Century Fox films. *Centennial Summer* had a major premiere featuring a motorcade from the Book Cadillac Hotel to the theater with stars Vivian Blaine and Phil Silvers in person. (Courtesy Fox Theatre Archives.)

TRIPLE-SIDED MARQUEE, 1961. The Fox was the first theater in Michigan to begin screening Cinemascope pictures. Major premieres included *The Robe* (1953), *Carousel* (1956), and *The King and I* (1956). The Fox was one of a handful of theaters to have a large triple-sided marquee. (Courtesy Fox Theatre Archives.)

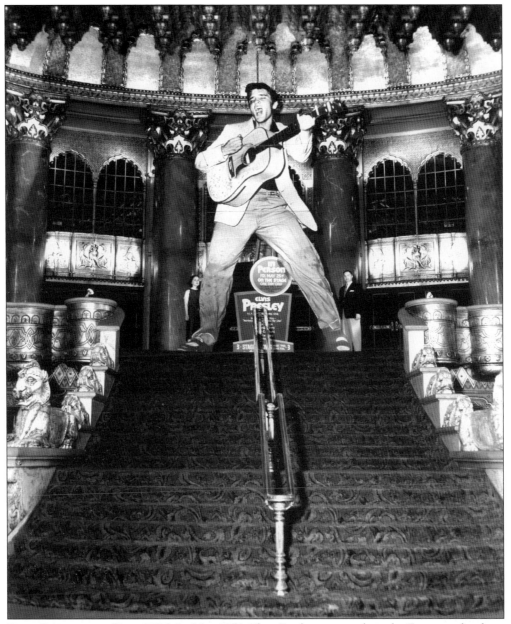

ELVIS STORMS THE FOX, 1956. In May 1956, Elvis Presley appeared on the Fox stage for three sold-out performances. All seats were a hefty $1.50, quite a bit for young folks back then. Over 13,000 screaming teenagers attended the performances. Presley received $10,000 for his appearance. Rock and roll was here to stay and paved the way as an additional revenue source for the Fox. (Courtesy Fox Theatre Archives.)

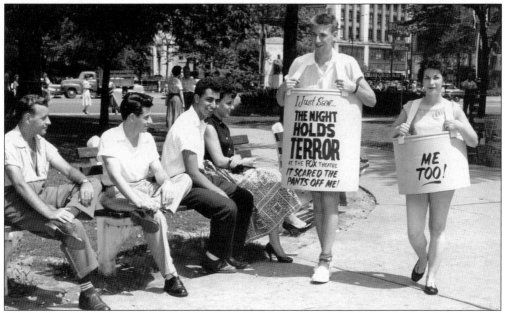

DOWNTOWN PROMOTIONS FOR EXPLOITATION FILMS. By the 1960s, the Fox was being run by an independent team of owners: Herman Cohen and Bill Brown. Cohen produced a number of exploitation films, including *I Was a Teenage Werewolf* and *Horrors of the Black Museum*, which he booked into the Fox since the studios had begun to write off the Fox for exclusive first-run pictures. (Courtesy Fox Theatre Archives.)

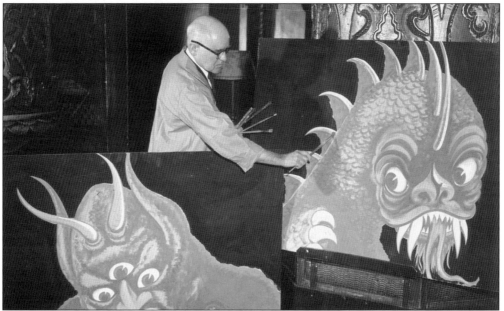

SIGN PAINTING AS AN ART, 1960. Walter Clinton, as seen in this image, was a custom sign painter at the Fox for many years. It was common practice for most of the large downtown houses to have a full-time sign painter on staff. Their job was to create large eye-catching displays for the exterior of the theaters as well as for lobby displays. This tradition continued at the Fox even through the kung fu years. (Courtesy Fox Theatre Archives.)

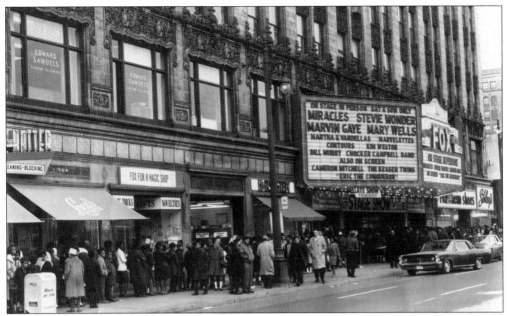

MOTORTOWN REVUES, THE 1960S. Early Motortown Revues at the Fox in 1964–1965 featured more acts than could fit on the marquee. A typical program would include the Temptations, Stevie Wonder, Martha and the Vandellas, J. J. Barnes, Gladys Knight and the Pips, Jimmy Ruffin, the Underdogs, Tammi Terrell, and the Earl Van Dyke Band. (Courtesy Central Business District Foundation.)

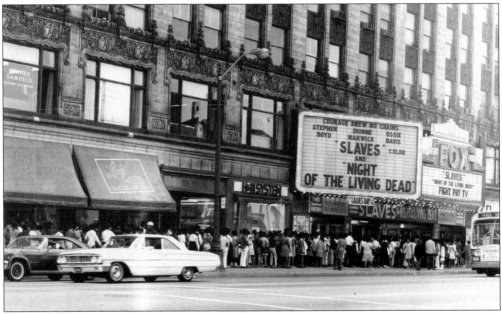

EXPLOITATION FILMS, THE 1970S. By the 1970s and into the 1980s, the Fox survived by screening horror, gore, action, and kung fu pictures. Films such as *Willard* (1973) would gross $100,000 in one week at the box office. Other fan favorites were the Pam Grier flicks churned out by American International Pictures. The Fox Office Building, once the home of regional offices for the major studios and booking agents, closed in 1976. (Courtesy Fox Theatre Archives.)

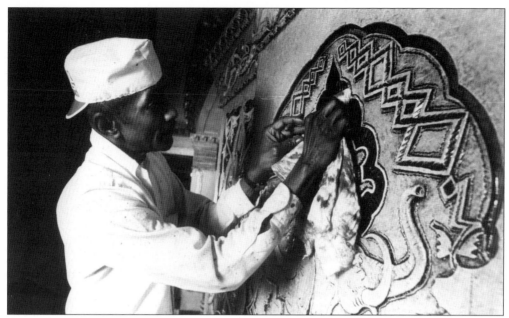

OSCAR GRAVES, PLASTER RESTORATION ARTIST, 1988. Oscar Graves was responsible for much of the plaster restoration at the Fox. His magic touch can be seen on statues, columns, ceilings, and wall moldings. His inspiration for restoration developed from a two-year military stint in Europe, where he studied the architectural wonders of Rome and Florence. A lobby plaque commemorates his achievements. (Courtesy Fox Theatre Archives.)

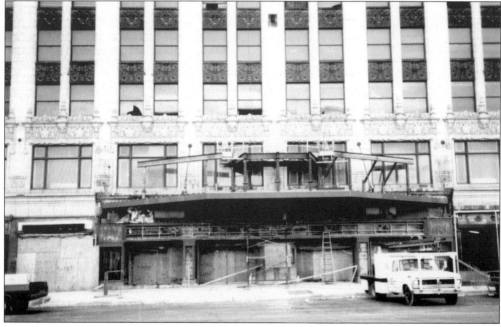

CREATING AN ENTIRELY NEW MARQUEE. In July 1987, Michael and Marian Ilitch purchased the Fox from Charles Forbes and began a $10 million restoration of the theater. The adjoining office building was renovated in 1989 and became Little Caesar Enterprises headquarters. (Courtesy Michael Hauser.)

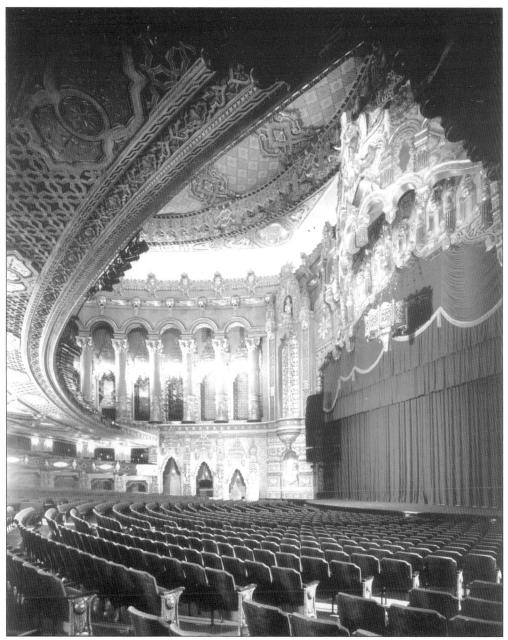

THE RESTORED AUDITORIUM, 1988. The Fox stage is 130 feet wide and is flanked by twin plaster figurine goddesses, encased in gold leaf. Above the stage towers a majestic gold elephant wearing a jewel-studded crown and below extends the world's largest incense burner (actually a decorative fixture), which once held sound equipment. (Courtesy Balthazar Korab/Fox Theatre Archives.)

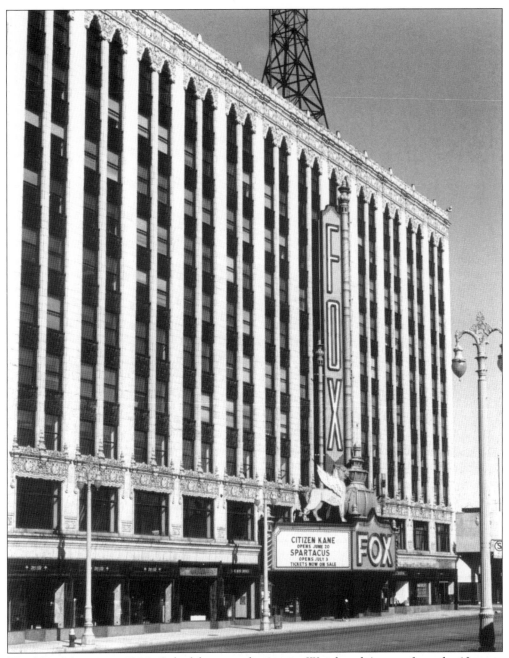

The New Marquee, 1989. Colorful neon radiates onto Woodward Avenue from the 10-story, 120-foot Fox blade sign. A pair of regal griffins guard the entrance to this sumptuous palace of dreams. In 2005, a two-year, $2 million restoration of the Fox's terra-cotta facade was completed, and in 2006, the 100-foot-tall rooftop tower sign spelling out Fox was renovated. (Courtesy Fox Theatre Archives.)

Six

THE UNITED
ARTISTS THEATER

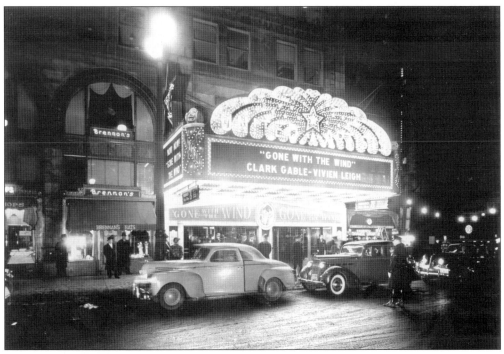

GONE WITH THE WIND DUAL PREMIERE, 1940. Demand was so strong for this picture that MGM booked the film into both the United Artists (at popular prices with continual showings) and the Wilson Theater (reserved seats for two screenings a day). Unofficial word was that Matilda Dodge Wilson called Louis Mayer and demanded she have a print of this picture for her theater. (Courtesy Manning Brothers Historical Collection.)

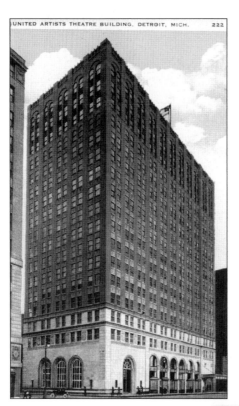

VINTAGE POSTCARD, 1928. This artist rendering of the 18-story United Artists Building depicts a modest canopy at the theater entrance with no signage whatsoever. The tower housed an assortment of offices and shops, including furriers, tailors, beauty salons, and travel agents. (Courtesy Michael Hauser.)

UNITED ARTISTS BLADE SIGN, 1929. This eight-story spectacular was 80 feet high and 7.5 feet wide, designed so patrons could spot it from Grand Circus Park and the Grand River Avenue streetcar lines. The multicolored bulbs in the sunburst-style marquee were accented with large stars and the word "hear" when talking pictures arrived. (Courtesy Manning Brothers Historical Collection.)

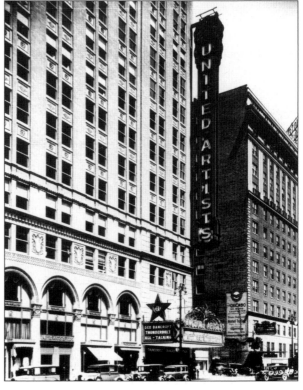

A 1950 View of the Sunburst Marquee. By 1950, large side panels had been added to the marquee. The 1930s and 1940s saw regional premieres of such films as Howard Hughes's *Hell's Angels* (1930), Cecil B. DeMille's *Cleopatra* (1934), Disney's *Snow White* (1938), *Boy's Town* (1938), *The Wizard of Oz* (1939), and Disney's *Pinocchio* (1940). (Courtesy Burton Historical Collection, Detroit Public Library.)

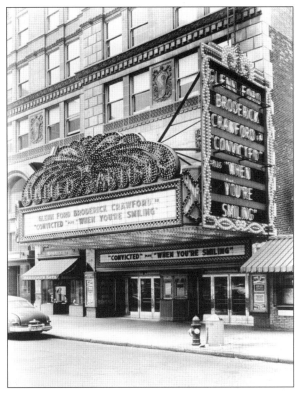

Auditorium Sidewall Detail, 1928. Architect C. Howard Crane designed the United Artists in a Spanish Gothic style. Visually the auditorium was a feast for the eyes, with plaster ornamentation covering every square inch of wall space. Monks and Indian statuary lined the sidewalls, with oversized lanterns providing an orange glow of mystery. (Courtesy Manning Brothers Historical Collection.)

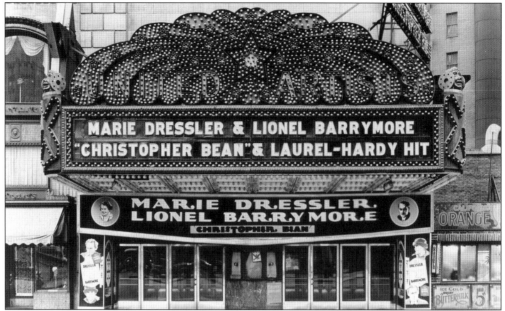

SHOWMANSHIP AT ITS FINEST, 1933. Detroit's United Artists was one of three flagship theaters constructed by United Artists Studios, with the others being in Los Angeles (now a house of worship) and Chicago (demolished). This studio was founded in 1919 by Charles Chaplin, Douglas Fairbanks, Mary Pickford, and D. W. Griffith—the four biggest names in motion pictures at the time. (Courtesy Burton Historical Collection, Detroit Public Library.)

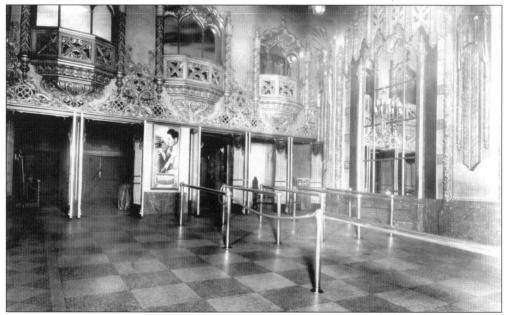

UNITED ARTISTS STORM LOBBY, 1929. This theater was built at a cost of $1.2 million and opened on February 3, 1928. Gloria Swanson pulled the switch to open the ceremony by remote from Los Angeles. The opening film was the world premiere of *Sadie Thompson*, starring Gloria Swanson and Lionel Barrymore. Symphonic accompaniment was by Hugo Riesenfeld, augmented by the Wurlitzer pipe organ. (Courtesy Manning Brothers Historical Collection.)

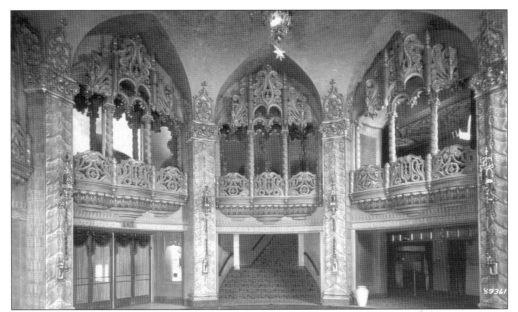

THE INNER LOBBY, 1928. The United Artists was built specifically for motion pictures. Promotional slogans for the theater proclaimed that it was "a shrine to the motion picture" and also "where the film is FIRST forever!" with "ALL the show on the screen!" The rotunda pictured here was renovated in 1950 so a large concession stand could be installed. (Courtesy Manning Brothers Historical Collection.)

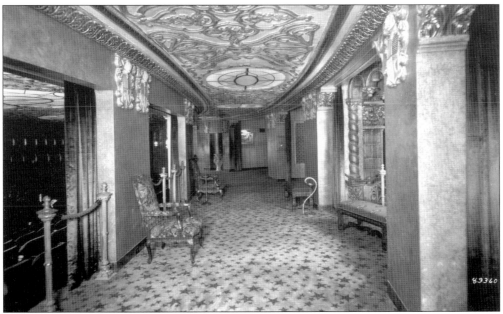

THE INTIMATE LOGE LEVEL, 1928. No expense was spared for patron enjoyment. The loge level was adorned with silk draperies, tapestries, intricate light fixtures, gilded plaster, and even stars in the carpeting. One could feel like royalty by paying 35¢ to attend a matinee or 65¢ in the evening. Smokers could pay an extra 10¢ to sit in the loge. (Courtesy Manning Brothers Historical Collection.)

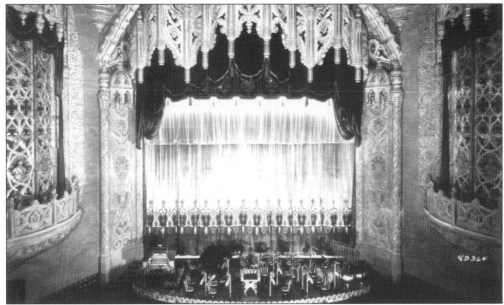

AUDITORIUM AS SEEN FROM THE BALCONY, 1928. The United Artists auditorium featured lacy, conical fan vaults, an elaborate gilded ceiling dome ringed with angels, and projecting canopies over the proscenium and organ grilles. The orchestra and the Wurlitzer organ were for film accompaniment, as this theater never produced stage shows. The organ contained 1,562 pipes with over seven miles of wire. (Courtesy Manning Brothers Historical Collection.)

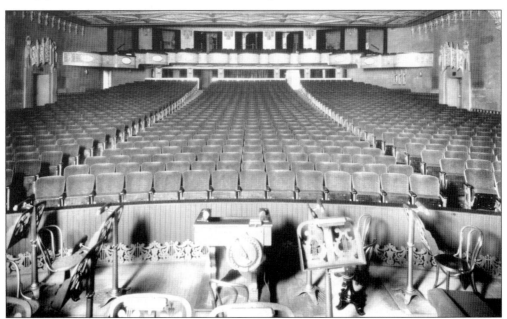

A VIEW FROM THE ORCHESTRA PIT, 1929. The original screen was 18 feet by 22 feet, and the stage was 30 feet deep. The orchestra section seated 1,242, the mezzanine accommodated 160, and the balcony contained 626 seats. This venue was referred to as the "jewelbox" of Detroit first-run theaters by the film industry because of its intimacy. (Courtesy Manning Brothers Historical Collection.)

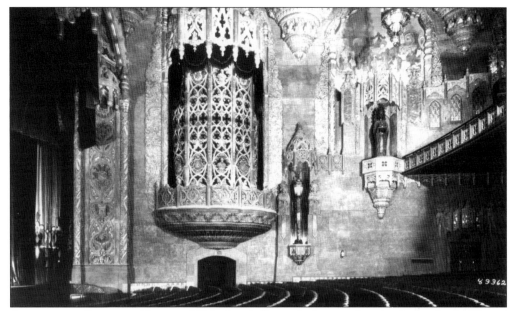

AUDITORIUM SIDEWALL DETAIL, 1928. Overkill was the key word in the design for the United Artists auditorium. The sole purpose was to attract and entertain large audiences. The theater was part of "the show," guaranteeing patrons that they would be whisked into a fantasy, unlike what was on the screen. Overscaled Indian maidens kept watch over devoted attendees with a confident smile. (Courtesy Manning Brothers Historical Collection.)

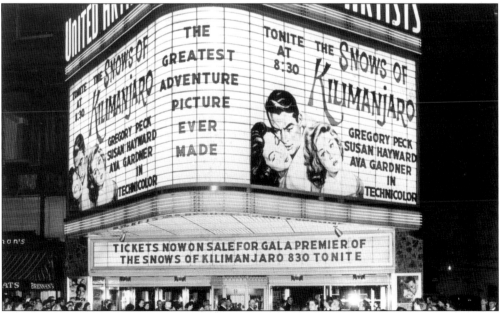

CUSTOMIZED MARQUEE, 1952. In 1950, the theater transferred ownership from United Detroit Theatres back to United Artists Theaters, which then embarked on a $200,000 remodel of the venue. The auditorium was under scaffolding for several months, the floor was reconfigured, a new marquee was installed, and new projection, sound, and Michigan's first glass fiber screen were installed. (Courtesy Burton Historical Collection, Detroit Public Library.)

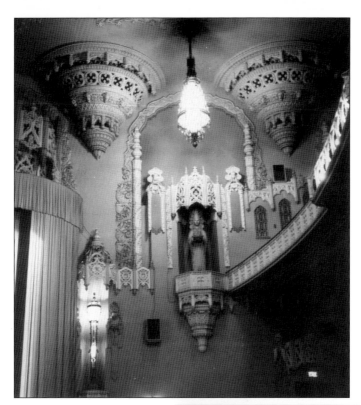

A LATER VIEW OF THE AUDITORIUM, 1967. The 1950s saw many premieres at the United Artists, including Otto Preminger's *Anatomy of a Murder* (1950), *How to Marry a Millionaire* (1953), *Around the World in 80 Days* (1957), and *South Pacific* (1958). This theater was the first in Michigan to screen films in 70-millimeter format with the release of *Oklahoma!* in 1956. (Courtesy Theatre Historical Society of America, Elmhurst, Illinois.)

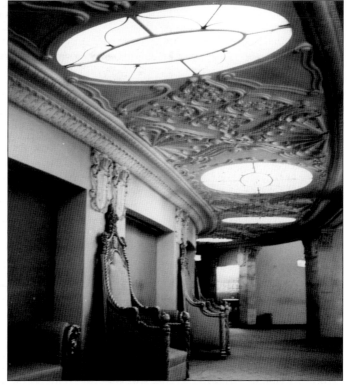

THE LOGE LEVEL, 1967. The 1960s saw many long-running reserved-seat engagements, including *Ben-Hur* (1960), *King of Kings* (1961), *Mutiny on the Bounty* (1962), *My Fair Lady* (1965), *Dr. Zhivago* (1966), *Hawaii* (1967), and *Camelot* (1968). In 1963, United Artists paid an astonishing $550,000 advance to 20th Century Fox for the exclusive Detroit engagement of *Cleopatra* at this venue. (Courtesy Theatre Historical Society of America, Elmhurst, Illinois.)

LOOKING UP TOWARD THE LOGE LEVEL, 1967. As these images attest, United Artists maintained the theater fairly well even toward the end, with many of the original furnishings and light fixtures intact. By 1969, however, business dropped dramatically, and the venue experienced some disastrous runs with road show engagements of *Goodbye, Mr. Chips* and *Tora! Tora! Tora!*. (Courtesy Theatre Historical Society of America, Elmhurst, Illinois.)

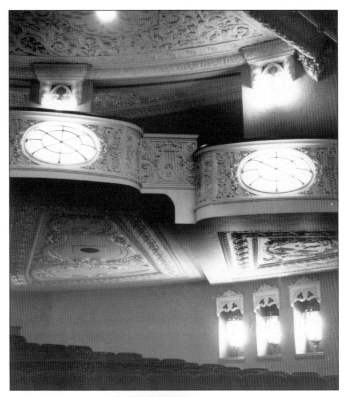

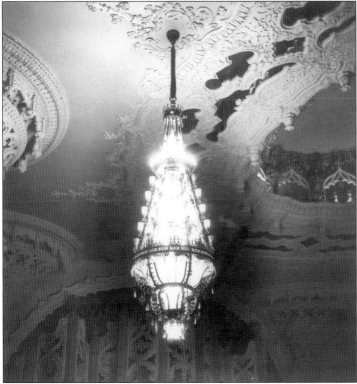

LIGHT FIXTURE DETAIL, 1967. Faced with product shortage in 1969, the theater abruptly ended first-run fare and shocked local officials by switching to pornography. Following a period of brief closures, this venue reopened in 1971 as a grind house, specializing in horror, gore, and action films. After 45 years of service to the community, the screen went silent for the final time in 1973 with the forgettable bill of *She Freaks* and *Dr. Jekyll & Sister Hyde*. (Courtesy Theatre Historical Society of America, Elmhurst, Illinois.)

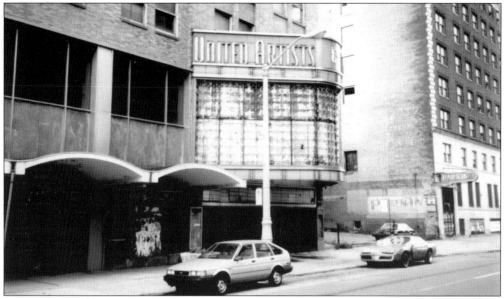

FROM CLASS TO PORNOGRAPHY TO DECAY IN THREE SHORT YEARS. In 1974, the American Automobile Club vacated the United Artists Building and moved its headquarters to Dearborn. This was the death knell for the theater as well, as all 18 floors of the office structure were now empty, and there was no caretaker for the theater. The property went through various owners in the 1970s and 1980s and occasionally made news because of falling bricks from upper floors. (Courtesy Michael Hauser.)

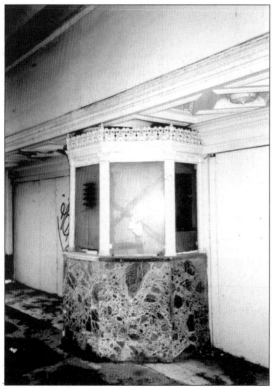

NO SALES TODAY. The Detroit Symphony Orchestra brought a spark of life to the theater when it began auditorium recording sessions in 1979. This use of the facility continued through 1983 when the symphony stated that it could not endure another session with no heat, little electricity, and snow and rain pelting the musicians from exposed holes in the roof. (Courtesy Michael Hauser.)

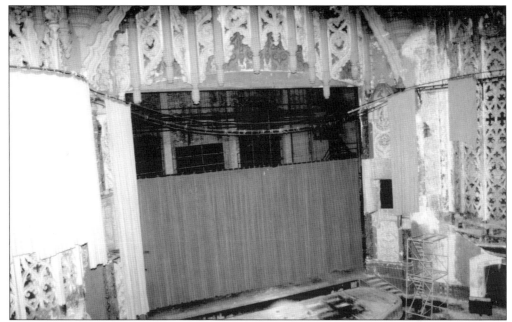

WATER-DAMAGED AUDITORIUM. This image from the winter of 1996 captures the state of the auditorium prior to the hard-core vandalism that occurred in later years. Despite the rooftop holes, a significant amount of original plaster was still intact. At this point in time, the statuary also had not been obliterated. (Courtesy Lance Myers.)

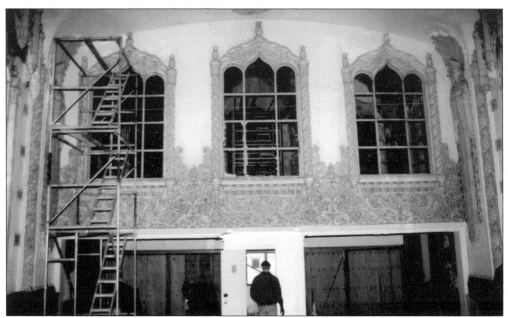

A HOPED-FOR REJUVENATION. In 1990, businessman David Grossman purchased the complex with the intent of restoring the theater and developing loft apartments in the office building. He began restoring the outer lobby and renovated the former National Bank of Detroit branch into a nightclub called the Vault. A hoped-for neighborhood renaissance, however, was not on the horizon. (Courtesy Lance Myers.)

THE DESTRUCTION CONTINUES. In 1997, Don Barden purchased the property and shortly thereafter transferred the United Artists to Ilitch Holdings. As seen above, the condition of the property continued to deteriorate with vandalism and squatters setting up living quarters in the office building. (Courtesy Michael Hauser.)

SUPER BOWL 2006 DISCOVERY. Amazingly, this once vibrant venue has been vacant for 33 years of its 78-year existence. In preparation for Super Bowl 2006, the colorful 1950 marquee was removed, and the majestic reliefs depicted above appeared, having been covered over since 1928. The property is now being marketed along with the former Hotel Statler for future development. (Courtesy Michael Hauser.)

Seven

THE WILSON THEATER

GROUNDBREAKING FOR THE WILSON THEATER, 1927. Matilda Dodge Wilson (widow of automobile pioneer John Dodge and, later, wife of lumber baron Alfred Wilson) attends the groundbreaking for the Wilson Theater in 1927. Her inspiration to construct this venue resulted from a European trip she took with several architects. She was determined to build an intimate venue for all forms of artistic expression. The stage of this theater is 80 feet wide and 40 feet deep, and the seating capacity is 1,700. (Courtesy Walter P. Reuther Library, Wayne State University.)

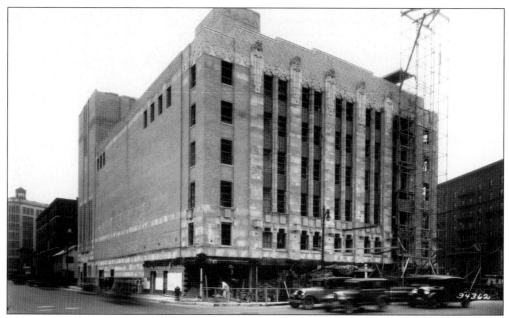

CONSTRUCTION OF THE WILSON, 1928. William Kapp designed this Spanish Renaissance theater at 350 Madison for the architectural firm of Smith, Hinchman and Grylls. At the time, this $3 million facility was state-of-the-art with attributes such as travertine, wood-paneled walls, silk draperies, thick carpeting, dressing rooms to accommodate 100 performers, and an orchestra pit that accommodated 40 musicians. (Courtesy Manning Brothers Historical Collection.)

CLOSE-UP OF GLAZED TERRA-COTTA, 1928. The exterior of the Wilson was adorned with beautiful glazed terra-cotta in color splashes of green and orange, surrounding the reliefs such as tragedy and comedy pictured here. Mankato stone was utilized on the Madison Avenue side of the theater, with brick on the remaining three sides. (Courtesy Music Hall Archives.)

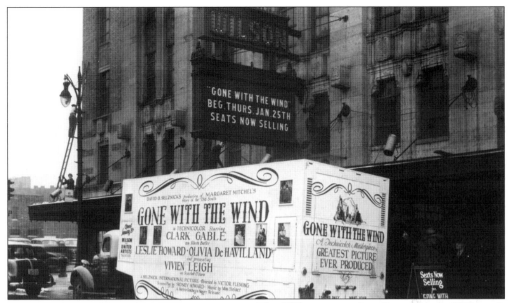

GONE WITH THE WIND SHOWMANSHIP, 1940. The Wilson opened on December 9, 1928, with *Rosalie*, a Florenz Ziegfeld production. The 1920s and 1930s saw other Ziegfeld productions as well as product from the Theatre Guild of New York. The first major motion picture to open here was Warner's *A Midsummer Night's Dream* in 1935. The San Carlo Opera Company also made occasional visits. (Courtesy Manning Brothers Historical Collection.)

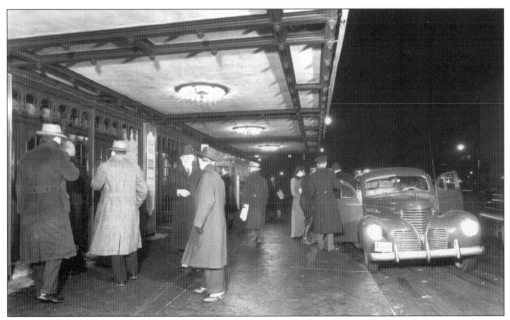

OPENING NIGHT FOR GONE WITH THE WIND, 1940. *Gone with the Wind* opened on January 25, 1940, and played day and date with the United Artists Theatre on Bagley Street. At the Wilson, all seats were reserved, and there were only two shows a day at 2:00 and 8:00 p.m. Prices ranged from $1.10 to $1.50, which were considered pricey for the time. This film had an unprecedented 12-week run at the Wilson. (Courtesy Manning Brothers Historical Collection.)

PREPARING FOR THE *FANTASIA* PREMIERE, 1941. The Wilson was one of 14 theaters in North America selected by Disney to host the premiere of *Fantasia* on February 18, 1941. Engineers installed the RCA Fantasound System, as seen on the stage above, which was the first utilization of stereophonic sound for motion pictures. (Courtesy Walter P. Reuther Library, Wayne State University.)

DETROIT SYMPHONY ORCHESTRA ARRIVES, 1945. In 1945, Matilda Dodge Wilson sold the theater to Henry Reichold, who renamed the theater Music Hall, as the new home for the Detroit Symphony Orchestra. Broadcast capabilities were added, allowing thousands to hear the symphony via the *Ford Sunday Evening Hour*. The year 1945 also saw *Winged Victory* play a sold-out engagement, which encompassed 300 performers, with proceeds going to U.S. Army charities. (Courtesy Michael Hauser.)

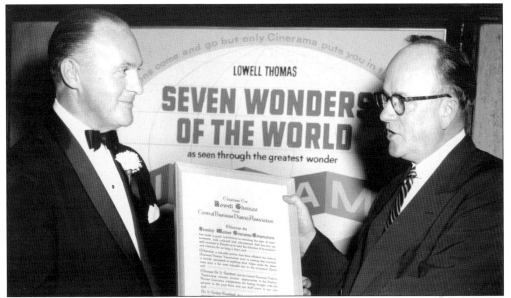

CINERAMA SAVES MUSIC HALL, 1953. By 1949, the Detroit Symphony Orchestra, unable to financially maintain its home, returned to the Detroit Masonic Temple. Music Hall filled the open dates with performers such as Billie Holiday and Spike Jones. In 1953, Mervyn Gaskin purchased the facility with the intent of booking theatrical productions. Instead, he was approached by the folks behind a new motion picture sensation called Cinerama, and Music Hall became the world's second Cinerama theater. (Courtesy Central Business District Foundation.)

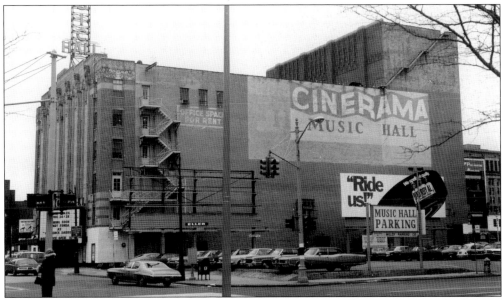

WHAT FOLLOWS AFTER CINERAMA? However, by the late 1960s, the Cinerama process became prohibitively expensive to produce. The theater experimented with conventional films and concerts. By 1970, the neighborhood become bleaker, and the theater closed. In 1973, after witnessing the success of Michigan Opera Theatre performances at Music Hall, a coalition comprised of the Kresge Foundation and Detroit Renaissance saved the venue and reinvented it as a nonprofit performing arts center. (Courtesy Central Business District Foundation.)

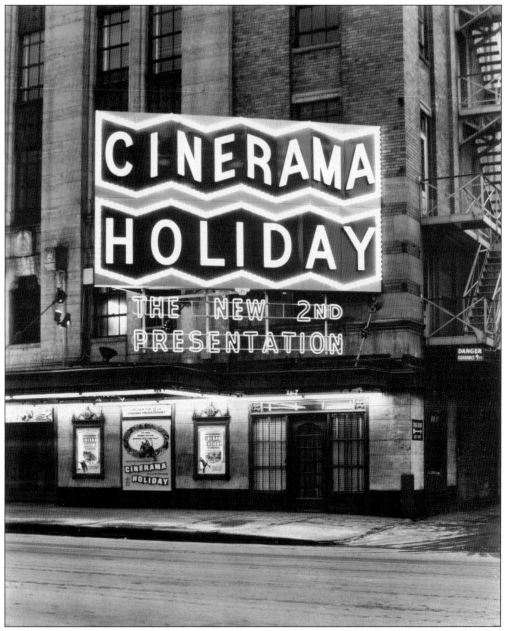

CINERAMA HOLIDAY SPECTACULAR, 1955. *This Is Cinerama*, the first Cinerama production, opened at Music Hall on March 23, 1953, and was a benefit for the Detroit Symphony Orchestra. The premiere drew local officials as well as Lowell Thomas and Cinerama executives. This picture played Music Hall for 100 weeks and grossed over $1 million. To accommodate the curved Cinerama screen, the side boxes were removed, and all decorative paint in the auditorium was painted brown. (Courtesy Walter P. Reuther Library, Wayne State University.)

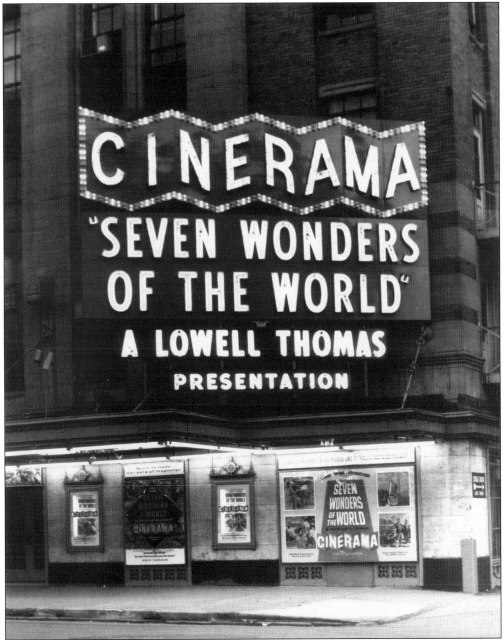

SEVEN WONDERS OF THE WORLD SPECTACULAR, 1956. Neon spectaculars such as these for Cinerama provided some pizzazz to the Grand Circus Park Entertainment District. Cinerama reinvigorated the film industry for a decade. The 1963 MGM release *How the West Was Won* was the final Cinerama product produced in the three-strip format. Following that, Music Hall played 70-millimeter blowups of such films as *It's a Mad, Mad, Mad, Mad World*, *The Greatest Story Ever Told*, *The Sand Pebbles*, and *The Lion in Winter*. (Courtesy Music Hall Archives.)

MUSIC HALL BRINGS LIFE TO DOWNTOWN. The resurrection of Music Hall in the 1970s brought nightlife back to downtown. Michigan Opera Theatre was the resident company of the venue from 1971 to 1985, bringing grand opera to Detroit. Dr. David DiChiera was also the artistic director for Music Hall and assembled seasons of Broadway, dance, and concerts. (Courtesy Michigan Opera Theatre Archives.)

RIDING HIGH, THE 1970S. Besides opera and theatrical presentations, Music Hall became the Midwest home for dance. Companies that graced the stage in the 1970s and 1980s include Martha Graham, Agnes de Mille, Alvin Ailey, Merce Cunningham, the Joffrey, Les Ballets Trockadero, New York City Ballet, Dance Theatre of Harlem, Jose Limon, San Francisco Ballet, Elliott Feld, Paul Taylor, Pilobulus, Twyla Tharp, Bill T. Jones, Garth Fagan, and countless others. (Courtesy Michigan Opera Theatre Archives.)

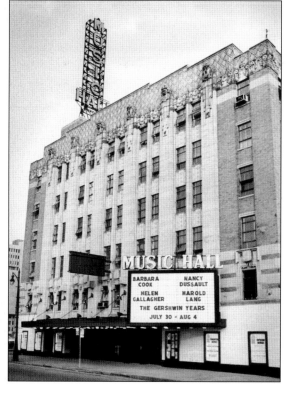

CLOSE-UP OF THE RESTORED AUDITORIUM CEILING, 1996. This image captures the details of the beautiful stenciling on the ceiling of the Music Hall auditorium. Some of these intricate details were covered over during the Cinerama era, and others were simply covered with 60-plus years of soot. The theater underwent a $6 million restoration in 1995. (Courtesy Laszlo Regos.)

AUDITORIUM UNDER SCAFFOLDING, 1995. Music Hall's auditorium was under scaffolding for months in 1995 to restore decorative plaster, restore stenciling, and re-create the boxes that were removed for Cinerama. The outer lobby was restored as well, along with reproduction wood doors and a reproduction of the modest 1928 marquee. (Courtesy Laszlo Regos.)

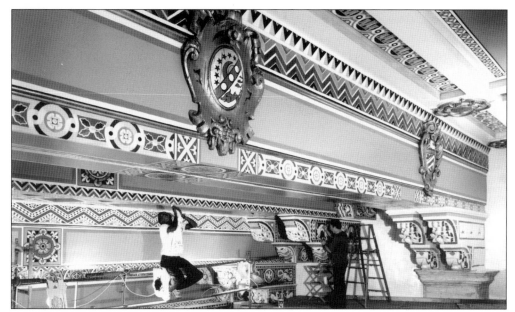

ARTISANS RESTORING THE CEILING DETAIL, 1995. Many patrons who marvel at the architectural wonders of Music Hall frequently mistake the stenciled panels in the auditorium for wood, but, indeed, they are plaster. The theater also boasts unique ironwork with the initial *WT* for Wilson Theater, original light fixtures, original Spanish tiles, and original draperies in the boxes. (Courtesy Laszlo Regos.)

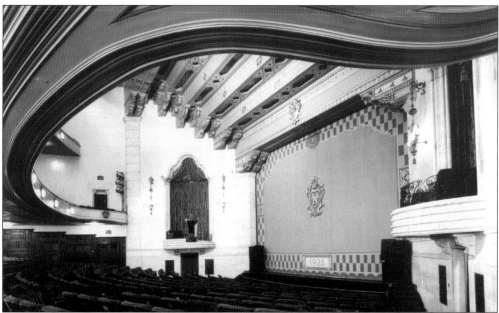

RESTORED AUDITORIUM, 1996. This view of the auditorium from house right showcases the new stage curtain that was installed as part of the 1995 restoration of the facility. Music Hall has once again taken its place as one the Midwest's premier variety houses, presenting all forms of entertainment to a wide variety of patrons for generations to come, just as Matilda Dodge Wilson wished for back in 1928. (Courtesy Laszlo Regos.)

Eight

The Gem and
Telenews Theaters

The Gem/Century as the Concordia Society, 1938. The Century portion of the Gem complex was built in 1903 by the Century Club, a women's organization dedicated to cultural activities. The Century owned this facility until 1938, when the venue was sold to the Concordia Singing Society (the Century Club organization disbanded in 1933 as a result of the Great Depression). Concordia operated here until 1948, when it became the Russian Bear Restaurant—a nightclub and restaurant for the Russian refugees who immigrated to the United States following World War I. (Courtesy Manning Brothers Historical Collection.)

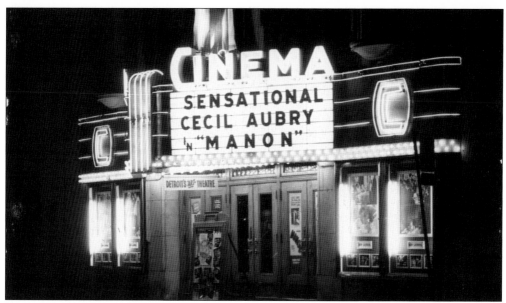

AS THE CINEMA THEATRE, 1950. The Gem Theatre was built in 1928 as an addition to the already existing Century Club, which used it as an auditorium for its activities. The Spanish Revival venue was designed by George Mason (who also designed the Detroit Masonic Temple) and constructed for an astonishing cost of $25,000. That same year, the Century Club leased the facility to the Motion Picture Guild, which operated the Little Theater chain of art houses and named the theater the Little Theater. (Courtesy Shan Sayles.)

CINEMA PLAYBILL, 1939. For over 30 years, this theater was Detroit's finest showcase for viewing foreign and independent films. The name of the venue changed often and for a period of time was known as the Rivoli (1932–1934), the Drury Lane (1935), the Europa (1936), the Cinema (1936–1959), and, briefly, as the World (1956). It enjoyed its greatest success while managed by Neil Talling, who was a showmanship genius—marketing the Cinema's films via postcards, playbills, and ethnic newspapers. (Courtesy Michael Hauser.)

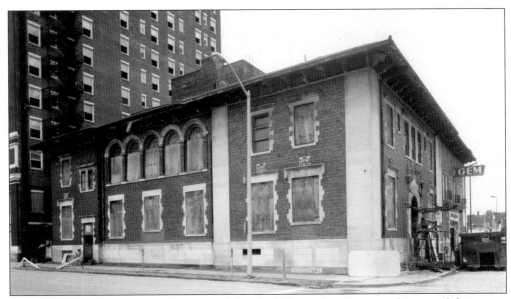

DESOLATION, THE 1970S AND 1980S. A bright light in the illustrious history of this venue occurred in 1959 when it became the Vanguard Playhouse, featuring residential and professional troupes. This unique company nurtured many actors who eventually moved on to Broadway and Hollywood. The Vanguard disbanded in 1964 and sat vacant until it became the Gem Art Theater in 1966, specializing in adult films. The conversion of pornography from film to video doomed this venue, and it closed in 1978. (Courtesy Manning Brothers Historical Collection.)

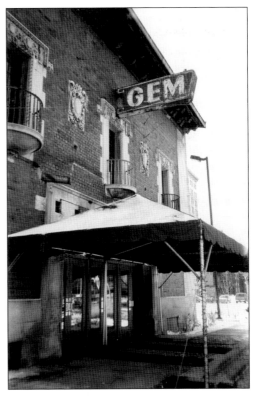

RENOVATED, 1991. The deteriorating Gem sat desolate for six years until retired businessman Charles Forbes purchased the theater from the City of Detroit in 1984. Forbes immediately secured the facility and in 1985 installed a new roof to stabilize the venue until funds were available for full-scale restoration. In 1990, the Forbes family and Ray Shepardson began a complete restoration of the Gem, which was then christened on New Year's Eve 1999, opening with *The All Night Strut!*. (Courtesy Michael Hauser.)

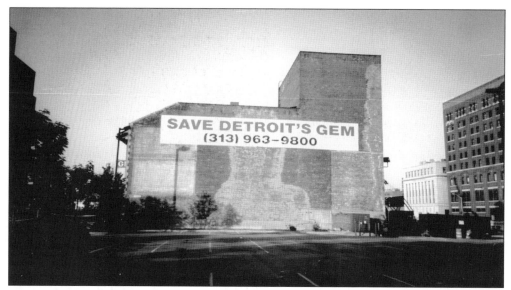

SAVE THE GEM, 1996. In 1996, the Forbes family was challenged with saving the Gem from a different force, the Stadium Authority, which wanted to demolish the "little theater that could" for a new Comerica Park baseball stadium. The Forbes family and many others in the metro community galvanized their efforts to save the venue by taking the Stadium Authority to court. Forbes won a judgment and received enough compensation to move the Gem/Century complex as well as the beloved art deco Elwood Grill, which Forbes had earlier restored. (Courtesy Michael Hauser.)

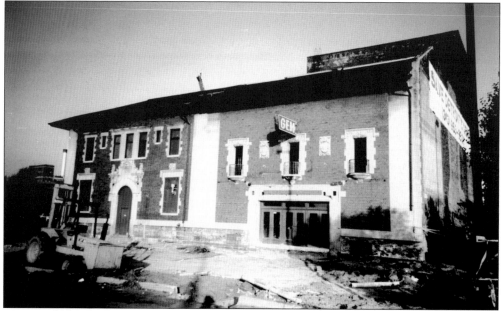

MOVING THE GEM, 1997. On November 10, 1997, the Gem completed its five-block journey from 58 East Columbia Street to 333 Madison Avenue, breaking the 1986 Guinness World Record as the heaviest structure ever moved on wheels. This historic move cost $1.6 million and spanned 13 days, utilizing 71 dollies, 568 tractor tires, and 18,000 oak planks, which were used to form the cribbing to support the structure. (Courtesy Michael Hauser.)

Auditorium Renovated Once Again, 1998. After yet another renovation following the move, the Gem reopened in September 1998 with *I Love You . . . You're Perfect, Now Change!*. There are 200 seats cabaret style on the main floor and 250 affixed theater seats in the balcony. This second restoration cost $2 million and took 15 months to complete. (Courtesy Balthazar Korab/ Gem Theatre.)

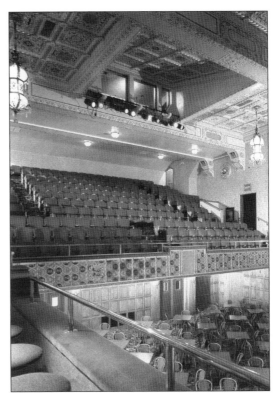

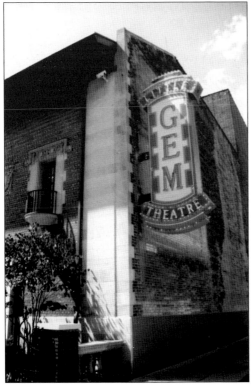

Little Gem Marquee, 1998. The Gem has hosted countless successful productions, many of which have created new long-run box office records. The adjacent restored Century Club Theater and dining facility opened in 1999, featuring *Forbidden Broadway* in the handsome 200-seat venue. Many of the architectural items throughout the facility were saved from the nearby YWCA, such as fireplaces, light fixtures, and decorative Pewabic tiles. (Courtesy Michael Hauser.)

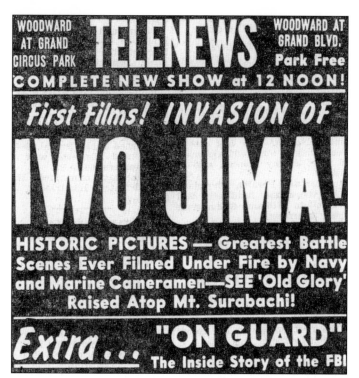

TELENEWS ADVERTISEMENT, 1945. Besides newsreels, a typical program consisted of local events, weekly commentaries, WXYZ Radio's *March of Time* and WJLB Radio's *Information Please!*. The outer lobby featured a teletype machine with wire photograph displays. The Telenews was part of a national chain and used headlines such as "a well informed public is America's best defense" and "the world is our stage!" in its publicity. (Courtesy Michael Hauser.)

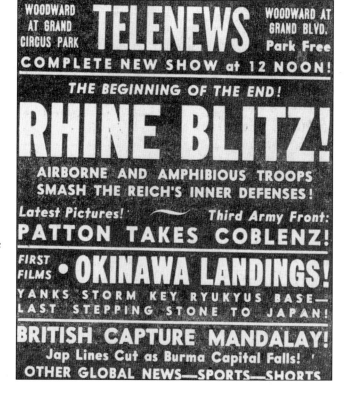

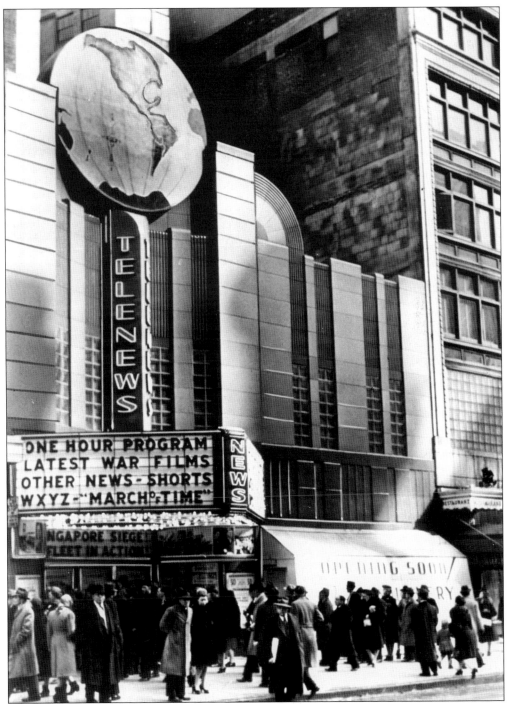

THE TELENEWS OPENS ON VALENTINE'S DAY, 1942. The Telenews, at 1540 Woodward Avenue, was the final theater constructed in the Grand Circus Park Entertainment District. This 465-seat art moderne gem was designed by Edward E. Schley, a partner of C. Howard Crane. The convex globe on the facade was a neighborhood landmark for years. The lower level featured a state-of-the-art broadcasting studio and a reading room. (Courtesy Central Business District Foundation.)

MARQUEE REMOVED FOR ADAPTED REUSE, 2000. Following the demise of newsreels, the Telenews opted for foreign and art films. By the late 1960s, it became increasingly difficult to book this theater. Nicholas George Theaters leased the venue in 1969 and renamed it the Plaza, initially a first-run showcase and later an action hardtop until its closure in 1987. Carl Allison reopened the theater in 1988 as the Tele-Arts, which had a brief run as an art house until 1991. (Courtesy Michael Hauser.)

THEATER EVOLVES INTO CLUB BLEU, 2000. From 1992 to 1998, Preservation Wayne featured the Telenews on its annual downtown theater tour. Owner Lorna Abraham graciously allowed volunteers to spruce up the venue each year. In 2000, $1 million was spent to convert the theater into a swank nightclub called the Bleu Room Experience, showcasing techno sound and light. It remains one of the metro area's most popular nightspots. (Courtesy Michael Hauser.)

Nine

LOST BUT NOT FORGOTTEN THEATERS

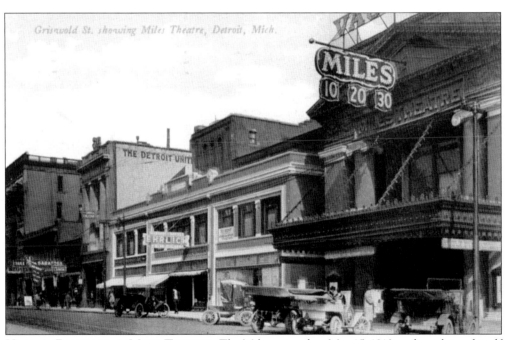

VINTAGE POSTCARD OF MILES THEATRE. The Miles opened on May 15, 1910, and proclaimed itself Detroit's home for "advanced vaudeville." This 2,000-seat venue, located at 1220–1222 Griswold Street, was built by Keys and Colburn Architects, with George Mason (architect for the Detroit Masonic Temple and the Gem Theatre) as the supervising architect. By the mid-1920s, photoplays were also added to the program. Unable to compete with all the other downtown venues, this theater closed in 1927 and was later demolished. (Courtesy Michael Hauser.)

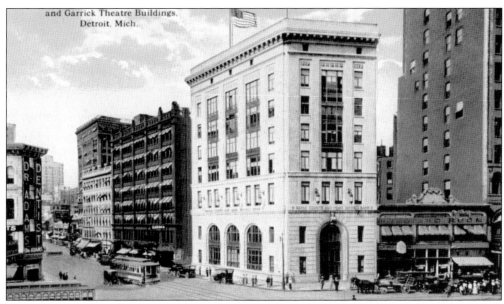

and Garrick Theatre Buildings.
Detroit, Mich.

VINTAGE POSTCARD OF GARRICK THEATRE. The Garrick, originally designed by J. H. Wood, opened as the Whitney Grand Opera House at 1122 Griswold Street on October 31, 1887. It was built by C. J. Whitney for melodrama presentations and was blessed with a 30-feet-deep stage. In 1909, the Shuberts acquired the house and hired Baxter and O'Dell to completely renovate the theater. E. D. Stair reopened the venue on September 6, 1909, as the Garrick Theatre. (Courtesy Michael Hauser.)

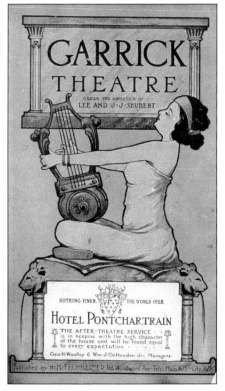

GARRICK PLAYBILL, 1911. The opening show for the Garrick in 1909 was *Mr. Hamlet of Broadway*. The seats were late in arriving, and the last row was installed moments before the first patrons were admitted. Jessie Bonstelle produced summer stock here before moving to her own midtown venue. Media accounts also list the Garrick as the stage where escape artist Harry Houdini gave his final performance in 1926. The theater was demolished in 1928. (Courtesy Michael Hauser.)

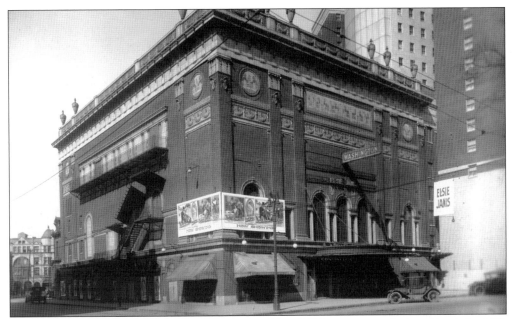

EXTERIOR OF THE FOX WASHINGTON THEATER. This 1,800-seat venue, designed by Arland W. Johnson, was located at 1505–1513 Washington Boulevard. It opened in July 1913 and from 1919 henceforth was renamed the William Fox, becoming Detroit's flagship for William Fox's films (of 20th Century Fox). This theater initially opened with vaudeville fare and featured a 35-foot-deep stage. (Courtesy Manning Brothers Historical Collection.)

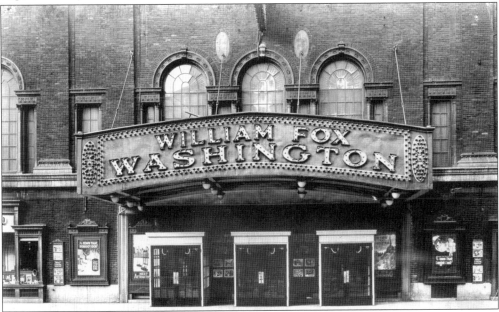

FOX WASHINGTON MARQUEE, 1922. The William Fox prided itself on showcasing "superior photoplay productions," with a complete change of program each Sunday. In 1928, this theater closed in preparation for the opening of William Fox's Fox Theatre on Woodward Avenue. The venue was eventually demolished and later replaced by a Stouffer's Restaurant, which flourished into the 1970s. (Courtesy Walter P. Reuther Library, Wayne State University.)

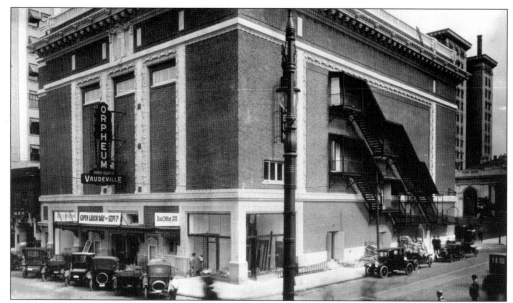

EXTERIOR OF THE ORPHEUM THEATER, 1914. The Orpheum, at 153 West Lafayette Boulevard, was built by Charles Miles and opened on September 7, 1914, as a home for vaudeville and photoplays. The architectural firm was Smith, Hinchman and Grylls. The seating capacity was 2,050 seats, which was later modified to 1,500 seats. In 1925, the Shuberts purchased and then renovated the venue, rechristening it the Shubert Lafayette with a lavish production of *The Student Prince*. (Courtesy Burton Historical Collection, Detroit Public Library.)

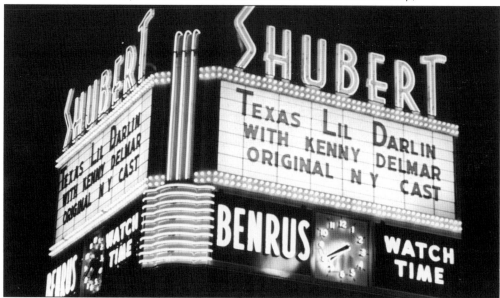

EXTERIOR OF THE SHUBERT THEATER, 1950. This venue was a break-in house for many years for Broadway-bound shows. The Shuberts experimented with various name changes, reverting back to the Lafayette in 1935, then to the Shubert Lafayette in 1942, and finally settling on the Shubert in 1952. A house record was set in 1962 with *The Carol Burnett Show*. The final booking in 1963 was *In One Bed*, and the theater was demolished in 1964. The Financial District Parking Garage sits on this site today. (Courtesy Central Business District Foundation.)

EARLIER GRAND CIRCUS THEATER, 1920. The "original" Grand Circus Theater was also an early C. Howard Crane design. Located at 2115 Woodward Avenue, it opened on February 23, 1913. It was renamed the Central Theater in 1921 and demolished in 1924 to make way for the Palms State Theater. (Courtesy Manning Brothers Historical Collection.)

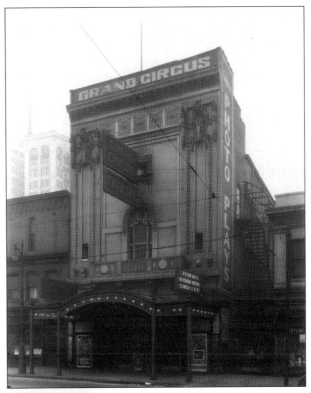

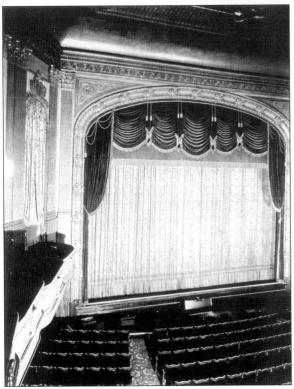

INTERIOR OF THE CASS THEATRE, 1933. The Cass was designed by theater architect Herbert J. Krapp, who had also designed a number of Broadway houses. It was built for E. D. Stair, a former owner of the *Detroit Free Press*, and opened on September 12, 1926, with a production of *Princess Flavia*, a Sigmund Romberg operetta. This was one of Detroit's principal legitimate theaters for years. (Courtesy Burton Historical Collection, Detroit Public Library.)

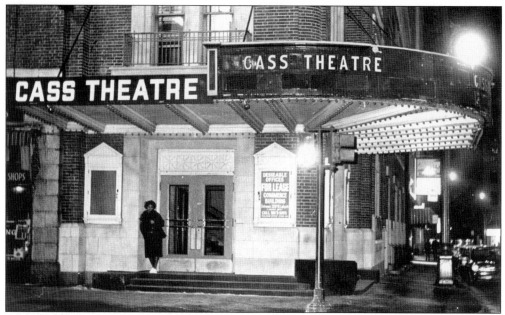

EXTERIOR OF THE CASS, 1964. The Cass seating capacity was 1,500, and it was located within the six-story Commerce Building at 300 West Lafayette Boulevard. Besides an impressive array of plays and musicals, the Cass also occasionally screened films such as *The Great Ziegfeld* (1936), *The Good Earth* (1937), and *The Life of Emile Zola* (1937). This theater closed in 1964. (Courtesy Burton Historical Collection, Detroit Public Library.)

AS THE SUMMIT THEATRE, 1966. In 1964, the Cass was acquired by Beacon Enterprises, which began a $250,000 renovation, under the direction of architect Drew Eberson. The venue reopened on March 1, 1965, as the Summit, specializing in 70-millimeter blowup Cinerama pictures. Thousands of Detroiters enjoyed films such as *Grand Prix* (1966) and *2001: A Space Odyssey* (1968) here. In 1970, facing a product shortage, pornography was screened until the theater closed in 1971. In 1974, the venue became the Pandora, specializing in Greek films, but by 1977, it was razed for a parking lot. (Courtesy Walter P. Reuther Library, Wayne State University.)

EXTERIOR OF THE ORIENTAL THEATER. The Oriental at 120 West Adams Street was designed by Percival Periera. This 3,000-seat house opened on September 26, 1927, and was heralded as "America's most distinctive theater!" Film industry folks deemed it a "hard luck house," as it was tough to consistently program. Everything from Keith's vaudeville to films to boxing was tried, but its location was too far west of Grand Circus Park. (Courtesy Manning Brothers Historical Collection.)

Hurry -- Rush -- Act Now!

WRITE - WIRE - PHONE TODAY
For Dates and Terms on

"Smashing the Vice Trust"

First Michigan Showing NOW PLAYING it's SECOND WEEK to CAPACITY BUSINESS at the DOWNTOWN THEATRE, DETROIT

Exploitation Possibilities Unlimited — Excellent Advertising Accessories — Trailers — Photos — Pictorial and Block Paper — Colored Enlargements, Etc.

Make Some Real Money — Every Live-wire Show Man Will Want to Cash-in on This Picture — NOW!

"SMASHING THE VICE TRUST"

NOTE — Do not confuse this excellent New Picture with any other of similar title.

ADDRESS

Wayne Road Show Attractions

MAURICE SILVERBERG FILM EXCHANGE BLDG. DETROIT, MICH.

HANDBILL FOR THE DOWNTOWN THEATRE. RKO acquired the Oriental in 1930 and renamed it the Downtown. Programming consisted of stage shows and films. In 1936, RKO renovated the venue and offered free drinks, pretzels, and cheese to induce patrons (this was several years prior to theaters installing formal concession stands). B and K Theaters managed the house from the mid-1940s until it closed in 1950. The theater was demolished in 1953. (Courtesy Michael Hauser.)

ACROSS AMERICA, PEOPLE ARE DISCOVERING SOMETHING WONDERFUL. *THEIR HERITAGE.*

Arcadia Publishing is the leading local history publisher in the United States. With more than 3,000 titles in print and hundreds of new titles released every year, Arcadia has extensive specialized experience chronicling the history of communities and celebrating America's hidden stories, bringing to life the people, places, and events from the past. To discover the history of other communities across the nation, please visit:

www.arcadiapublishing.com

Customized search tools allow you to find regional history books about the town where you grew up, the cities where your friends and family live, the town where your parents met, or even that retirement spot you've been dreaming about.